God at Home

By

Sylvia Diamond

Illustrations by Elizabeth Diamond

**Grosvenor House
Publishing Limited**

This book is published by
Grosvenor House Publishing Ltd
Link House
140 The Broadway, Tolworth, Surrey, KT6 7HT.
www.grosvenorhousepublishing.co.uk

A CIP record for this book
is available from the British Library

ISBN 978-1-83975-556-9

The image featured on page vi and the Front cover, by Sir John
Everett Millais, Bt<https://www.tate.org.uk/art/artists/sir-john-everett-
millais-bt-379> Christ in the House of His Parents ('The Carpenter's Shop')
1849–50 is reproduced with kind permission from The Tate Gallery.

ACKNOWLEDGMENTS

As the family grew, so did this little book. Our shared life was the soil in which it took root and developed. My deepest appreciation goes to them and to the family in which I grew up, for all that we experienced and learned together - through struggles and fun and failures.

The writing halted many times, as other commitments crowded it out, but spurs to continue came from our daughters and I am deeply grateful to them for their continued help. Lois solved many computer problems for me. The enforced time at home, during the Covid-19 pandemic proved to be a gift for Elizabeth; an opportune time to use her fine artistic gifts and training to produce the illustrations which have added so much to the theme of each chapter.

I am also greatly indebted to Elizabeth's husband, the Reverend Tim Harling for his unfailing encouragement. Despite a full workload as Dean of Chapel, at Queens' College, Cambridge, he undertook the first task of copy-editing and, with Elizabeth, looked after all the plans for publication.

Someone once said that sharing the good news of the gospel is simply one hungry person helping another to find bread. It is in this spirit that this little book is sent out.

CONTENTS

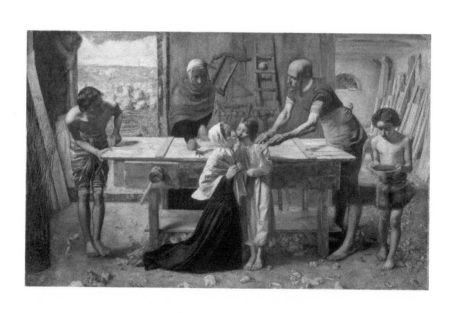

INTRODUCTION

There is a homely scene in one of the Tate Gallery's great works of art. John Everett Millais' painting *Christ in the House of his Parents* shows the child Jesus being comforted by his mother, Mary. Joseph is holding the boy's small hand, revealing an injury to the palm, apparently sustained while using one of the carpenter's tools. Mary's mother, Anne, is looking on in concern while his young cousin John (the Baptist) anxiously carries a bowl of water towards them.

The painting is rich in visual detail – the carpenter's bench and his tools, the stacked timber on the sawdust-scattered floor and a glimpse of sunlit countryside beyond the open door. It is also redolent with symbolism; there are nails and planks of wood, while drops of blood fall from Jesus' palm onto his foot; the water carried by John hints at later baptism, and there is even a triangular set square hanging above Jesus' head, suggesting the Trinity.

But there is meaning enough in the painting even without the hints of later events in Jesus' life. It is a real workplace, such as one could find in many towns and villages in the 21st as well as the 1st century, with tools and rolled-up sleeves, work-worn hands and debris on the floor. The one in which Jesus worked for most of his life in Nazareth could not have been very different.

However, when the painting was shown at the Royal Academy in 1851, some critics were outraged. *The Times* art critic wrote, 'Mr. Millais' principal picture is, to speak plainly, revolting. The attempt to associate the holy family with the meanest details of a carpenter's shop, with no conceivable omission of misery, dirt or even disease, all finished with the same minuteness of detail is disgusting.'[1]

Clearly, this critic lived a life sheltered from the realities of manual work. A carpenter's shop is inevitably filled with the tools of his trade – the 'mean details' of saw and nails, hammer and plane. And in every age and society until the recent era of mass production, the furniture in every home, simple and grand, from rough bench to the most intricately carved cabinet has been crafted in this way. Dust and dirt are part of the process. The gospels themselves show us Jesus dealing constantly with the realities of 'misery, dirt and disease' In fact, the painting gives just a glimpse of the real human life that God really entered into in Jesus.

But perhaps the most crucial question that arises is, what did the critic mean by 'holy family'? The implication of this criticism is that somehow Jesus, Mary and Joseph, together with the younger children of their family (mentioned by all the gospel writers) were not real human beings in a normal home with dust and flies, grimy hands and hard work, lively family mealtimes, laughter and play, accidents and tears. *The Times* critic seemed not to understand that this material and human world so familiar to us is the very one God made and loves, in which he came to make himself known in Jesus and became 'God with us'.

We see from the gospels that the people of Jesus' home town did not in fact see anything extraordinary in this family. Excavations in nearby Capernaum reveal a very small 1st-century community, little houses closely clustered together. Residents in Nazareth would have known one another extremely well. So accustomed were they to these neighbours, with the children growing up in their midst, that they were amazed and mystified when Jesus left his workshop and began his public work of teaching and healing.

"Is not this the carpenter's son?" they asked one another. "Is not his mother called Mary, and are not his brothers James, Joseph, Simon and Judas? And are not all his sisters with us? Where then did this man get all this?"[2] Mark tells us that some asked, 'Is not

this the carpenter?'[3] They recognised him as a local craftsman, a member of a family they knew well. Now they heard his wise teaching and saw the miracles of healing, but they stumbled at the next step of recognising that the great God of their fathers, whom they worshipped in the local synagogue, was now speaking to them, his transcendent power at work among them. 'And they took offence at him. And he could do no deed of power there ... amazed at their unbelief.'

So, both the 19th-century art critic and the people of Jesus' town fell into the same trap of incomprehension and unbelief, though over different obstacles. The first did not understand God's immanence, that Jesus was truly human as well as divine, here with us in the real world. The others were too wrapped up in this real world to recognise and receive the transcendent power and presence of the living God when it was before them and available to them.

The Times art critic was not alone in his incomprehension of the literally down-to-earth reality of the human life of Jesus, including his family life. The idea persists today that God, if he exists at all, is in a distant heaven – that holiness, if it is thought of at all, is an isolated other-worldliness – and that if God can be known at all, it will most probably be in a church or religious community rather than at home, on the street or in the workplace.

Your God is Too Small is the title of a book by J.B. Phillips, the well-known translator in the 1950s of the Bible into modern, vibrant English. We could also add 'and too churchy'. I hope that together in the following pages we can recognise that God is still at home in his world, that he still makes himself known and works alongside us in our homes and streets and workplaces, that the home in particular is the main arena of his work in teaching and training and revealing himself to his children – that in fact, as our forebears the Celtic Christians experienced, *'the edge of glory is found at the level of the ordinary'*.

Notes

1 Laurence Des Cars: *The Pre-Raphaelites: Romance and Realism*: (Thames and Hudson.) p.32
2 Matthew 13:53–57 NRSV
3 Mark 6:3 NRSV

CHAPTER 1

WHY FAMILIES?

In our first ten or so years of living in a little street near the centre of Cambridge, every house contained a family or elderly couple or a widow whose family had grown up but, in many cases, lived nearby. At around 4 o'clock each day all the children would drop their schoolbags at home, have a quick snack then run off to the nearby Common, or to the building site on its edge where new houses were slowly rising, to meet their friends, plague the workmen, and invent a variety of imaginative games involving balls, ropes, trees and often lots of mud. Over every garden wall, their voices, laughter and quarrels could be heard, a welcome sound to many, grumbled at by a few.

After another decade there were no school-age children in the street, and most houses had become temporary homes to students or shared by young working people for a couple of years. A few streets away, a new estate had been built for single-parent families, while just down the road, large groups of disconsolate-looking people of all ages were congregating near a hostel for the homeless. A second one was planned for the area. A mile or so away at a Christian youth and community centre, a much-needed new initiative was being developed. A support project for young, single mothers, mostly still teenagers, and their babies provides regular meetings for friendship and company, the teaching of parenting skills and practical help of all kinds – all of which in the fairly recent past would most probably have been given to young parents (both of them) by their own mums and dads, aunts, uncles and grandparents living nearby.

This small area of a medium-sized city seemed to be reflecting rapid, country-wide, demographic change and even disintegration of both family and community life. Scarcely a week goes by without an article appearing in a national newspaper either bewailing the breakdown in family life or, more radically, questioning whether strong family units are much needed anymore. The statistics are well known. Strangely, however, all the card shops in the nearby shopping centre have long racks of cards for Mum, Dad, and every other possible relationship as far as grandson-in-law. There seems to be a widespread sense of need to hold on to these relationships and a feeling that they are still of great importance.

So, why families? A fine painting in the National Gallery gives a profound wordless answer to this question. *The Heavenly and Earthly Trinities* by the 17th-century artist Bartolomé Esteban Murillo shows the child Jesus standing between Mary and Joseph, who are holding his hands – the earthly trinity. Above his head there is a glimpse of heaven. God the Father looks down upon his Son as the Holy Spirit in the form of a dove hovers between them – the Heavenly Trinity. We see here a representation of the amazing truth that family love originated before the universe existed and springs now from God himself. God did not just create families as human structures completely separate from himself. Family life flows out of his very nature, love and communication having always existed between the three persons of the Trinity.

'Without the Trinity, Christianity would not have the answers that modern man needs,' states Dr Francis Schaeffer in his book *Genesis in Space and Time*. He contrasts the concept of an impersonal universe where 'there is no explanation for personality' with the Judeo-Christian tradition foundational to our Western culture, which answers that 'the universe had a personal beginning on the high order of the Trinity.' Therefore 'Love and thought and communication existed prior to the creation of the heavens and the earth.'[1]

In the lovely Genesis account of the beginning of all things, there is the oft-repeated refrain, 'Let there be...', 'Let there be...', 'Let the waters bring forth...', 'Let the earth bring forth...', and it was so, at God's word. But when the earth is ready and teeming with life, the words God speaks are new, quite different and very significant. '*Let us make humankind in our image, according to our likeness*'... 'male and female he created them',[2] with the power to reproduce and become 'family', all together showing forth the love, the diversity and unity, the creativity and beauty of '*us*' – God the Holy Trinity – in a fullness that one human alone could not.

When small children play together and the activity begins to flag, you will often hear an excited voice above the others as a brilliant new idea comes, 'I know, *let's...*' There is a sense of almost the same kind of excitement as one reads this Genesis account, allowing one's imagination to soar over the far cold planets, the illimitable reaches of space, and then the baking deserts and deep green jungles of this world as well as the softer, gentler landscapes as they come into being with their countless creatures and plants of every kind and colour. Then, when all is ready, we again hear God's voice:

'*Let us* make humankind... male and female... be fruitful and multiply and fill the earth.'[3] And he created, in his own image,

families, to live in and people this earth-home, to nurture and enjoy it, under his direction and care.

Since getting the foundations deep and strong is vital to the stability of any structure, it might be wise to linger a little longer over this basis for 'family'. Families are under intense pressure as never before and are more likely to survive the stormy blasts if we can get certain foundation stones very firmly in place. The first is this understanding that families are not just 'the basic units of society' as politicians have sometimes been very ready to assert – though sometimes then undermining them by unhelpful financial and other legislation – but that they are the very crown of God's creation, reflecting his image in a unique and lovely way because he is the three-persons-in-one God and he made us this way to be like him and in some measure to reflect him within the variety of shapes and sizes that 'family' can take.

Then, as if to underline this intention in an unmistakable way, when families had become so fractured, and the image of God so marred in every way, God's Son came into our midst – in a *family*. One of the Heavenly Trinity became one of an earthly trinity or, simply, family. One could imagine other ways in which God could have made himself known, and he had done so throughout Old Testament times through prophet-messengers and his dealings with his chosen nation. But this was now his perfect plan. 'In the past, God spoke to our ancestors in many and various ways by the prophets, but in these last days he has spoken to us by a Son, whom he appointed the heir of all things, and through whom he also created the worlds.'4 'And the word became flesh and lived (made his home) among us.'5 If the first foundation stone of the family is the Trinity (our three-persons-in-one God who made us in his image), the second is the Incarnation or, to put it more simply, God's own Son being born as one of us, thereby putting his seal again on the family as his special creation.

We have all cried 'Nobody understands me'. Children, teenagers, wives, husbands all know this painful frustration, when everyone

else is too wrapped up in their work or interests to listen to and enter into our need. But when everyone else fails, as they often do, we have this solid rock of certainty that Jesus has been there before us, experiencing every age from infancy upwards. We can reflect on his development in Mary's womb, his helpless infancy in her arms, his toddling through the sawdust behind Joseph; we can picture him struggling to read the scrolls at the synagogue school, listening to sometimes tedious teachers, gradually learning domestic and carpentry skills from Mary and Joseph, and his first attempts at cooking the fish or crafting his first wooden bowl or stool. Through adolescence and early adulthood, he knew all the fun and laughter, the misunderstandings and disappointments of family life, and this awesome knowledge alone, together with his power to help, can keep us standing when life is very rough.

'Help!' is the often-silent cry of many a parent but it is increasingly hard to find. Families are scattered and sympathetic grandparents often far away. 'Because he himself has suffered... he is able to help.' Suffer does not only mean 'bear pain', it also means 'allow' or 'tolerate'. Toleration is a much-admired quality today, but perhaps practised less in family life than it used to be. What we don't like or grow tired of we now tend to walk away from. But in his family life we see Jesus 'finding and treating as endurable' (a definition of tolerance) all the joys and pains of growing up with, and then working alongside, fallible parents and family – 'His experience making Him perfectly equipped... to help.'[6]

In his introduction to a talk on the Bible at our church in Cambridge a former Bishop of Ely, the Right Reverend Stephen Sykes, said, 'The Bible says everything, but through a few great truths encapsulated in a people's lives.' Abstract truths can inform our minds, but we need to see them lived for them to touch our hearts and show us how to live them. All God's truth was encapsulated in Someone people could see and hear and touch. This great passage in Hebrews speaks of Jesus destroying death and making atonement for our sins, great life-transforming truths.

But it ends with these simple words for our everyday lives – 'he is able to help'.

Notes

1 Dr Francis Schaeffer: *Genesis in Space and Time* (Hodder and Stoughton). p.18, 21
2 Genesis 1:26, 27 NRSV
3 Genesis 1:28 NRSV
4 Hebrews 1:1.2 NRSV
5 John1:14 NRSV
6 Hebrews 5:8,9 AMP

CHAPTER 2

THE CELTIC CONNECTION

Foundations are deep and hidden. They are the solid ground on which the building rests, the lowest, load-bearing part of a building, usually below ground-level. Paul speaks of God's household the church being built on the apostles and prophets – inspired, godly people whose lives and teaching are the bedrock for his people – the cornerstone being Christ Jesus himself who holds the whole building together.

If we think of a family as a mini 'God's household' can we find other such godly people, whose lives and example can provide solid foundations for our families? People who are, in fact, usually deeply hidden from our view?

At first sight, a monastic community would seem to have very little in common with an ordinary modern family! We visit the beautiful ruins of Rievaulx or Fountains Abbey in Yorkshire and try hard to imagine lives lived there so vastly different from our own. Surprisingly though, as we look more deeply into their carefully balanced lives of work and prayer, self-sufficiency and hospitality, of education and care for the needy, we can find clear signposts directing us towards developing a healthy balance of work and family in a very rounded and productive life. However, an attempt to find our examples even further back in time than these might seem at first to be romantic and unrealistic.

We are, though, daring to look for help from our earliest Christian ancestors in these islands, our Celtic Christian forebears. The era in which they lived has usually been called the Dark Ages, the era of pagan violence which followed the Roman occupation of the

British Isles. The Romans had enforced order on warring tribal Britain, subduing revolt and changing the face of the land with fine roads, stone and brick-built villas and towns and efficient administration. Some had also brought the Christian gospel, and we learn of a priest in Verulamium who was given shelter from persecution in the home of a pagan man. This courageous man, named Alban, not only became a Christian believer through the priest's teaching but also took his place when soldiers arrived, allowing the priest to escape. Brave Alban was then martyred in the priest's stead, on the hill where St. Alban's abbey now stands.

Remains have been unearthed which speak of a significant Christian presence among the Roman occupiers. Foundations of early Roman settlements at Silchester in Hampshire and Lullingstone in Kent suggest that both had a Christian church. There are Christian symbols worked into a mosaic pavement which was found beneath a field in Hinton St Mary, Dorset. Now in the British Museum, this 4th-century mosaic shows a figure believed to be of Christ, as next to it the Chi Rho symbols are worked into the mosaic. The Christian presence seems to have been widespread as, further east, in Water Newton in Cambridgeshire, a fine 4th-century silver plaque was discovered bearing a clear Chi Rho symbol. We have now a tantalising glimpse of an even earlier Christian community in Britain. At a recent excavation of a Roman bathhouse at Binchester near Bishop Auckland, Co Durham, a silver ring set with a stone of carnelian has been unearthed, dated to the third century. Into the stone an anchor and two fishes have been incised, symbols of a Christian presence decades before Emperor Constantine's edict in AD 313 legitimising Christianity throughout the Empire. In fact, the Church in Britain was of sufficient size and organisation to send three bishops to a great council at Arles in the south of France in AD 314.

But Roman buildings and lifestyle were largely obliterated after the legions' departure to defend Rome from barbarian attackers in the years leading to AD 410. Thus, the so-called 'Dark Ages'

began. Fierce pagan tribes from the Continent swept into our shores, rapidly destroying the physical and social structures they did not value or understand. Our age cannot readily be compared to 5th, 6th and 7th-century Britain, except perhaps in a sense of loss – of having known, in some significant ways, better and more stable times.

Every era has brought threats and challenges to home and family life. Even some of our own great-grandparents could have been witnesses to child labour in cotton mills and mines and may have experienced grinding poverty. Writers of the time like Charles Dickens brought graphically to a wide readership the hazardous lives of orphaned children[1] or of families who had fallen into debt.[2] Others such as Elizabeth Gaskell were also unwaveringly truthful in portraying the harsh realities of workers' lives in the newly industrialised cities, while also telling of the mutual care of neighbours and extended family who cared for sick and needy and made life bearable.[3] However, today, in the midst of technological marvels and greater material comfort, better health and longer lives than we have ever known before, in 'post-Christendom' Britain we are aware of a sense of loss in our communities especially in the areas of faith, of family life and social cohesion

But our ancestors of the Dark Ages all those centuries ago were not plunged into unbroken night. In the midst of social breakdown, violent upheaval and unwelcome invaders, we find some bright pinpoints of light. 'Don't let the world around you squeeze you into its own mould but let God remould your lives from within,' the Apostle Paul told the Roman Christians.[4] The tiny groups of Christian believers in post-Roman Britain must have felt painfully squeezed, first by the pagan beliefs of their own people, then by the threats of fearsome invaders. To avoid obliteration, many surviving Britons fled west into Wales and Cornwall, Christians among them. Here the gospel remoulded them. And most historians agree that eventually large areas of this violent, disordered land, especially in the north and west, were gradually transformed by these faithful followers of Christ. As individuals,

they might have achieved little, but the lives and teaching of the small communities which gathered around them penetrated the gloom and changed the lives even of former unbelievers and enemies.

Our world is being shaken too. Old certainties have splintered apart. Many shared values have dissolved. Institutions that were generally revered – political, financial and religious – have proved weak and fallible and are often viewed with cynicism. Structures which held together families and communities are crumbling. There are threats from outside too, either from terrorism or potential natural disasters. More dangerous even than these are the unwholesome and undermining ideas which creep into our minds and homes uninvited and often unrecognised, rather like toxic fumes spreading through a house, which cannot be seen or even smelt but silently steal away health or even life. They creep unwittingly into our thinking and influence our lives through friends and school, workplace, media and internet, all together forcing a worldview upon our children and families which is alien to the life for which we were created and redeemed.

Our Celtic Christian forebears can help us! They can inspire us to resist the squeezing and show us how to build our lives and families on rock, not just to survive the storms and threats ourselves but to be bright beacons of light and hope and help to others.

Notes

1 Charles Dickens: *Oliver Twist. David Copperfield*
2 Charles Dickens: *Little Dorrit*
3 Elizabeth Gaskell: *Mary Barton: North and South*
4 Romans 12:2 J.B. Phillips *Letters to Young Churches'*

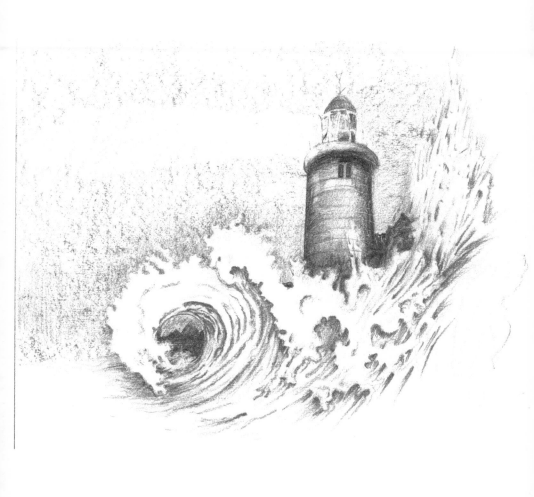

CHAPTER 3

ST. NINIAN

OUR LIGHTHOUSE

On the south-west corner of the island of Jersey, on large rocks some five hundred yards from the shore, stands the tall white lighthouse of La Corbière. Built in 1873, it was the first concrete lighthouse in the British Isles and much needed, as the surrounding rocks are open to racing tides and Atlantic storms and had over the centuries caused the wreck of many ships and the loss of countless lives. Visible for 18 miles, the light of La Corbière has over the years saved many ships and lives.

A lighthouse cannot control the sea around it. It cannot calm storms or soften the sharpness of fearsome rocks and reefs. In the days of manned lighthouses, a keeper who spotted a ship in trouble could not leap into the sea and physically steer it out of danger. All he could do was to keep the light burning brightly, to reveal the dangers and show a safe passage through treacherous waters.

Christian families today can often feel daunted and helpless as they live surrounded by tides of unbelief and secularism which they cannot control. Can a Christian home and family in some small way be 'a lighthouse'? A small community founded in Pictland in the 4th century (now part of Scotland) might provide some pointers even for a family 'community' today. A young Briton named Ninian, born about AD 360, left his noble parents to undertake a pilgrimage to Rome. The Venerable Bede wrote of him in AD 730 as a 'most reverend and holy man who has been regularly instructed in the Christian faith in Rome'.[1]

15

However, it was on his way home to Scotland that Ninian found the model for his future life and work. It is recorded by his 12th-century biographer, Aelred of Rievaulx, that he stopped in Tours, northern France. Here he found St. Martin and his Big Family, a Christian community purposely designed to be distinctive from the few urban churches which, in Martin's view, had already become comfortable and ineffective. Martin of Tours' vision for his Big Family was for it to be a Christian presence and witness in rural Gaul, among peoples so far untouched by the Christian message. As tales were told of the holiness of the lives lived there, of kindness shown to people in need, of healings and other evidence of God's power, more and more visitors flocked to his 'Big Family' from all over Europe.

Certainly, all that Ninian did on his arrival in Galloway indicates that he had been fired by Martin's example. He built a church and dedicated it to St. Martin. With a school and other buildings established as his base for life and work among the Picts, he named it Candida Casa – the 'White House', or Whithorn as it later became, named surely after Martin's White House near Tours. Even the sites are similar, with Ninian's cave a few miles from the church in a bay near a full stream reminiscent of Martin's first site at Marmoutier. More importantly, Ninian's manner of life and methods of work seem closely modelled on Martin's.[2]

The land of the Picts to which he was sent had largely escaped Roman influence. Hadrian's Wall had been built to protect these far reaches of Roman civilisation from the fierce tribes of Pictland. However, Roman references to these alien people speak only of their warrior-like attributes and ignore the fact that they were a largely pastoral people with fine artistic and metallurgic skills. Beautifully worked brooches and rings and chains have been found from this period as well as domestic tools and ornaments. But although linked by trade with the Empire, the Picts seem to have remained untouched by Christian influences until Ninian's arrival. Without any knowledge of God, their hearts would no doubt have been darkened and their lives blighted by the 'envy,

murder, strife, deceit and malice'[3] Paul speaks of so graphically in his letter to the Romans.

How Ninian achieved such success among these people can never be fully known, but Bede records that by AD 565 when St. Columba began his mission among the northern Picts, 'The southern Picts who live on this side of the mountains (the Grampians) are said to have abandoned the errors of idolatry long before this date and accepted the true faith through the preaching of St. Ninian.'[4] Through preaching alone? Almost certainly not. Words alone rarely convince or convert. As with Martin's 'Big Family' the quality of the lives of Ninian's monks and lay brothers as they used their skills to build and garden and fish and cook, to teach and care for the needy would have spoken volumes. Such ways of making known the good news of the gospel was succinctly expressed in the wise counsel usually attributed to St. Francis of Assisi: 'Preach the Gospel at all times – and where necessary use words.' Both the attribution and wisdom of this saying is sometimes challenged, but surely the underlying truth that Christ's good news is to be expressed in our lives in every loving and practical way possible cannot be questioned, even though the preaching and 'gossiping' of the gospel must always accompany them in order to make him known.

In churches and chapels in every town and many villages in our land, the word of God will be preached every week. But only a tiny percentage of our neighbours will ever hear it. In contrast, there are hundreds of thousands of Christians in homes of every size and shape scattered throughout the country. Jesus' command to his followers to 'let your light shine before others so that they will see your good works and give glory to your Father in heaven'[5] doesn't necessarily suggest words either – but it does say that our lives and homes can be very effective both with and without them. Every home to some degree will need the same practical skills as those of the lay brothers of Ninian's White House – if not masons

and smiths, certainly some lesser DIY skills, together with cooking and, for many homes, gardening. And every home will have neighbours. Can these humble activities, home-making skills, upbringing of children and neighbourhood relationships 'glorify your Father in heaven', in other words, make known to our neighbours something of who he is?

A family lived in a small house in an unremarkable little street in an unfashionable area of a famous city. Not far away, tourists marvelled at fine old buildings, but this area was under blight. Houses were boarded up, squatters had moved in, shops were empty, and gloom had descended. One house stood out in this little street. It was clean and freshly painted and every window held a window-box filled with flowers. Anyone passing through that depressing area on the way to nearby shops would have their spirits raised a little; they would sense a hope that life here could be better and brighter. On Sundays, this family could be seen walking slowly to church with their disabled son, a silent witness to the reason for their hope and resistance to the surrounding gloom – a little shaft of light.

A few streets away in the same parish lived another couple who attended the same church. They were regularly seen on their bikes, often with flowers tucked into the baskets. They were known over a wide area and people would speak of them with a smile. Neither was well-educated, but cheerfulness, friendliness, a kindly interest in whoever they met and a quiet readiness to meet any need that came their way marked their lives. Often their names were mentioned when the vicar visited in that area, and he learned that they were visiting sick people, doing shopping for the housebound and taking flowers to any who needed cheering. Certainly, his own task of 'preaching the gospel with words' was made easier.

* * *

Unwittingly, these people were witnessing the Celtic way. All the evidence points to a deep love for and study of Scripture in early

monastic settlements, but it seems that their strong emphasis was on living out what they believed. Not for them were lengthy, learned theological debates. Perhaps they had especially noted the 'therefores' in Paul's letters to the churches. After almost every carefully reasoned argument or explanation of doctrine Paul has a 'therefore'! The first chapters of his letter to the Romans assert and explain the basic Christian truths of our need for and God's way of salvation. But chapter 12 begins with 'therefore' and continues with the practical outcome of this doctrine – the thinking humbly of ourselves, using our varied gifts for one another and simply loving one another warmly, as well as being patient in trouble and joyful and prayerful always, with a generous, forgiving attitude to those who harm or hurt us. His emphasis seems to be on the quality and style of our lives rather than the knowledge in our heads! His long discourse on Christ's resurrection, and ours, in 1 Corinthians 15 ends with the whole point and purpose of this teaching: 'Therefore my beloved be steadfast, immovable, always excelling in the work of the Lord because you know that in the Lord your labour is not in vain.'[6]

So 'what kind of people ought you to be?' is Peter's question. After his careful teaching about the Day of the Lord in his second letter, he challenges his readers to work out their response in daily living. 'So ... make every effort to be found blameless, spotless and at peace...'[7]

The Celtic Christians' strong, constant emphasis was on the living out of doctrine in relationships and in the small things of everyday life. St. Columbanus stated that the Christian life was to be lived not theorised and debated. Many a minister's spouse could wish for a plaque on the living room wall with that saying writ large! Taking trays of coffee and biscuits to the clergy assembled for a lengthy meeting, between hanging out the laundry, entertaining the baby, mentally preparing the next meal and watching the clock for the dash to school – while the talk goes on. Doing the school-run, then clearing the cups and piling them in the sink, answering the phone with the baby on a hip – and the talk goes on! I've a

suspicion that one of those Celtic monks might have slipped away from the debate to wash the dishes, bring in the laundry when the rain started, tell stories to the children – and perhaps even take the baby and soothe him to give the parent a rest!

Would such activities suggest a less-than-keen attention to 'God's work'? Amy Carmichael of Dohnavur, a missionary in India in the early 1900s, faced this question. She had been part of a markedly successful evangelistic team working first in Japan and then south India. Now her work was among children, rescuing those in danger of being sold into temple service. The increasing numbers of children needed care, nursing and education – but this urgent and precious work was considered 'demeaning' by the local churches. At last, an elderly widow came to help. But, as Amy Carmichael records, 'one weekday morning, at the busiest hour, the village church began to ring its bell for some extra service, and she came to me at once. Her face wore its Sunday expression, and she had her Bible and Prayer-book under her arm. Five distracted babies for whom she was responsible were on a mat on the floor ... urgently demanding bottles ... but "I wish to go and do God's work," she said ... and we saw her face no more.' The prevailing belief was that 'God's work' meant church and teaching and preaching not working with your hands. In attempting to challenge this attitude, Amy Carmichael and her small team would say 'God didn't make you all mouth'![8]

How heartily would our Celtic Christian forebears have agreed! But neither were they all hands. The overriding impression gained by a study of their lives and work is of a steady, healthy balance. Energetic, self-sacrificing service towards others was balanced by long periods of withdrawal into a quiet place of prayer and meditation, usually somewhere beautiful, within sound and sight of rhythmic tides or rushing streams – close to nature and open to God's voice through his creation as well as through Scripture. Like Martin at Marmoutier, Ninian had his cave, just a few miles from Candida Casa on the seashore. Here he could listen to God and

receive vision and strength for his work and the strategy which eventually led to the founding of Christian settlements throughout southern Pictland.

* * *

A farmer's wife was slicing mounds of runner beans ready for blanching and freezing. We were sharing stories of work and home and children when she suddenly asked, 'Where do you escape?' Before I could make a rather uncertain reply, she added, 'I have my airing cupboard.' I had a fleeting vision of trying to squeeze between piles of sheets above my hot tank! But, leaving the beans, she took me up two flights of stairs to the attics. Her 'airing cupboard' was the size of a small bedroom, a large hot tank in the centre surrounded by drying rails. And in the corner by a little window overlooking quiet fields stood a much-used old armchair. Her cave! She was a busy farmer's wife, caring for elderly relatives and mother of four children now grown up but often still filling the house with their own families. Her husband was a church elder, and the house was often the venue for church meetings and social occasions, while it was also a welcoming home to visiting speakers and many visitors, including ourselves, whose summer holiday that year was spent camping on their farm. Somehow in the midst of hard work and many demands, she had an air of calm and quiet kindness, which could only have been inspired and fed and refreshed alone with the Lord in her airing-cupboard 'cave'.

Our modern houses and flats rarely have room for any kind of 'cave', not even a large airing cupboard! But if space can be found for the television and the computer, perhaps thought can be given to creating a quiet space, one area free from the intruding voices of media or games. It might well be one's own bedroom. If so, a chair with Bible at hand, near the window, so that at least the sky and shapes of clouds can be seen or the sun's warmth felt, might become one's retreat – with the mobile phone turned off and a 'Do Not Disturb' sign on the door!

In addition to quiet spaces, we need quiet times. Even in a busy family, perhaps an understanding can be reached that certain times are quiet. This used to be Sunday – a blessed oasis for many busy people. Now that Sunday for most people is as noisy and activity-filled as weekdays, this is much harder. Christian families will often attend church together. But they can also look for other ways to make it a different, special day – perhaps to enjoy the best family meal of the week, a time to play or walk or make something together – and also to create quiet spaces in it for reading and reflection. On weekdays too, certain ground rules can be set that each individual has the right to an undisturbed quiet time, either first thing in the morning if they are early risers or, for a parent working from home, in a lull after the schoolchildren have left, or at bedtime for the children – or whatever other time can be set aside. Parents with full-time jobs need very creative thinking to make this happen (see Jo's story*). The absolutely crucial thing is just that, to *set* it aside. Jesus told us to go into our room and to shut the door in order to pray. He called his disciples to come away for a while to be with him alone. If Jesus himself had waited till all the sick were healed, he would never have gone up into the hills to pray. He turned his back on the clamouring crowds to be alone with his Father for hours, sometimes all night. So did the Celtic saints.

The life-saving beams of light shining from lighthouses around our coast would fade and fail without a constant inflow of power and many ships and lives would be lost as a result. They have been lit by paraffin and gas and electricity and more recently by solar-powered batteries. But the power source is crucial if the light is to shine. As well as revealing himself as the Light of the world, Jesus tells us clearly that we are lights too.

How fitting that when Prince Charles visited Whithorn, where Ninian brought light to Pictland, the children of the primary school chose to sing for him 'Walk in the Light'! Our Celtic forebears lit and transformed the Dark Ages. St. Ninian's hours in his cave alone with God show us the way to keep that light bright.

To create:

A cave!

* Where possible a chair by a window with a view of countryside or a park or some trees – or just the sky and passing birds – to quieten our minds and lift our thoughts to our Creator.

*Where no peaceful view is possible, a place away from phone and computer, some flowers nearby, and something to help keep us focused – a picture of Jesus, a cross or a lovely seascape or landscape, anything that helps to tether wandering thoughts.

*Children need a 'cave'! The most likely time and place will be bedroom and bedtime. If this time is made a priority for a story they can look forward to when tucked-up and an unhurried time to talk over the day with Mum or Dad, it is less likely to be contentious – then a Bible story, perhaps with age-relevant notes and activities – then songs and prayer, teaching that everything big and small can be taken to Jesus. This precious time will become a welcome, cosy retreat at the end of the day, wired into their routine and memory.

* Jo's story

'Juggling four children, their schoolwork, my college course and assignments – never has my need of time alone been greater or, even more, my desperate need to carve out time and space with God. At times, I've crept downstairs early … only to be instantly found by a child. One day I sensed God say, "Share this time with your daughter, tell her what you are doing and why; invite her into it."

'Worship music helps me to focus … so does talking to God out loud when I declare God's promises over the household and each member. Sometimes, I can take a quiet walk outside … sometimes, the shower is the only quiet place … or time has to be carved out of sleep. Time and space must vary, but they need to be found.

'But when life crashes in, allowing no time at all alone, I'm comforted to know that I can talk to him as I go, as I work, listening for his help with every demand. Sharing all my worries, emotions, responsibilities and dreams with him enables God to work and lightens my load.'

*Here is a suggestion from another friend for a 'virtual cave':

'I often find it hard to focus ... a wise Benedictine friend asked me, out of the blue, what I did when talking on my mobile phone, especially when having an important conversation with someone I love. More to the point, he asked me what I physically did. Now this frustrates my wife, but when I'm talking to people on the phone and concentrating, I walk around very slowly and often in a repetitive motion (for example around the coffee table or between two rooms). When I told my friend about this, he then asked why I was surprised that I often struggle to pray in the conventional sitting or kneeling position. He said that if I naturally focus – both listening and speaking and asking for guidance – while slowly walking, why do I not do this with prayer – since prayer is listening, speaking and asking for guidance with our most loved one?

'I suppose this is my 'virtual cave'.'

Notes

1 Bede: *Ecclesiastical History of the English People:* Penguin Classics, p.148
2 Diana Leatham: *They Built on Rock:* (Hodder and Stoughton) p.38
3 Romans 1:29 NIV
4 Bede: Ecclesiastical History of the English People: p148
5 Matthew 5:16 NRSV
6 1 Corinthians 15:58 NRSV
7 2 Peter 3:14 NIV
8 Amy Carmichael Gold Cord: (S.P.C.K.) p.41

CHAPTER 4

ST. MARTIN OF TOURS
A BRIDGE FROM OUR PAST

Who do you think you are? Well-known people in the media or political life have recently been led by BBC researchers on a journey into their family's past, making amazing or sometimes distressing discoveries about their forebears. These have been fascinating for the people concerned and often for the viewers also.

'Who do we think we are?' DNA testing can now identify our bloodline, revealing largely Celtic, Anglo-Saxon, Viking, African, Asian or other ancestors from further afield for the present British population, sometimes even pinpointing the rural area from which a family came.

Does it matter? Beyond causing momentary surprise or interest, does this knowledge of our family history and genetic background have any present significance for us?

It seems that the biblical writers thought so. The long sections of genealogy in the Old Testament are usually skipped over in both church and private Bible readings as boring and irrelevant. Certainly, the long list of names with which the Gospel of Matthew begins seems an unappealing start to a book and we always begin the Christmas story later on in the first chapter with: 'Now the birth of Jesus Christ took place in this way.' But for Matthew, it was essential to his purpose to place Jesus in the royal line of King David and as a true son of Abraham, in order to show the thread of continuity throughout God's dealings with his people and that now his promises through the prophets had been fulfilled in this birth, in this family.

Any continuity in our history has been largely lost sight of in the school history teaching of recent decades. It became fashionable to teach selective episodes in an unchronological fashion, resulting in a poor understanding of who we are and why. Now there are signs of a change in attitude and moves are afoot in many schools to return to a more sequential teaching of our island's story, focusing on the people and events that have shaped us as well as placing our history in the context of significant European and global events. In the media, often a bastion of all that is modern, populist and irreverent, the more serious and well-presented history programmes are proving surprisingly popular. One passionate advocate of the thorough teaching of history is the historian Simon Schama who has claimed that 'We are completely wired to know our ancestry, what's actually flowing through our blood. It's like wanting to rifle through your granny's suitcase in the attic.'

The personal histories unearthed in *Who do you think you are?* prompted thousands of viewers to research their own ancestry. A more recent venture has encouraged research into community history. People have been asked to search out photos they may have tucked away in old albums or attic boxes, then scan them and upload them on to a relevant Google street view, adding to it their story behind the photo and a caption. Viewers can then immediately see connections between our present lives and communities and those of earlier generations in our towns and villages. The intention behind this new venture is to try to bridge the gap between generations. It seems that the young often have negative or even scornful perceptions of the elderly, and the old have an uncomprehending and often wary attitude to the young. There is a poor exchange of stories, views and culture, therefore minimal understanding and respect.

In order to overcome this sense of disconnectedness and rootlessness, we need to find our bridges to the past and our connections with other people and, most importantly, to discover the roots of the structures and values which have shaped us. Perhaps this is more important than ever at a time of fast,

momentous change and a sense of loss of the things that once did link us more closely to the past and to one another.

* * *

Here to help us comes Martin, the 'father of our Celtic saints'! In his book, *Martin of Tours,* Christopher Donaldson writes: 'Anyone who has cause to study the history of the fourth century must be struck by the unique sense of rapport that exists between that century and ours. Many intelligent people living in the fourth century had the same overpowering feeling with which we are familiar that they had arrived at a point where major and dramatic changes were about to take place in the whole order of things. On the one hand, they were conscious of being rooted in a centuries-old Graeco-Roman culture, yet they were becoming more and more aware that their feet were on the threshold of a new age ... in which nearly every familiar landmark – physical, moral and spiritual – was about to be swept away. Christianity was to provide the main formative influence in the centuries that lay ahead.'[1]

It was into this rapidly changing world that Martin was born in AD 316 on the west bank of the Danube, now in Hungary. Martin's early life was shaped by his pagan military family there on the eastern fringe of the Roman Empire, then their move to Ticinum, now Pavia, in Lombardy where he was educated and then enrolled in the Roman army at the age of fifteen. By that time, however, he had met with Christians. In Pavia, as elsewhere, many had suffered in the dying years of Emperor Diocletian's cruel persecutions and the young boy Martin must have been deeply impressed by many stories of faithfulness in suffering and of brave martyrdom. He was now witness to the transformation in church and society affected by Constantine's dramatic victory over rivals and his arrival in Rome in AD 312 as Caesar. A vision of the cross before his decisive battle had brought Constantine to sufficient belief in the God of the Christians to decree that all persecutions must cease. Christians and their churches were now

looked upon with favour. Drawn by all that he heard and saw of their life and teaching, at the tender age of ten, Martin enrolled as a catechumen in the local church in Pavia.

So, it was as a well-taught Christian that Martin entered the army of his fathers at the age of fifteen. This was the army of the same Empire which just a few centuries before had conquered Palestine, the same in which one centurion was commended by Jesus as having greater faith than any he had seen among his own people – and who had provided a synagogue for Capernaum families, the remains of which can still be seen today. Another centurion was recorded as proclaiming 'Surely this was the Son of God' as he watched Jesus die under Roman crucifixion.

Martin's life is like a massive bridge – at the far end lies the Roman world, which had framed and shaped New Testament events, while at the nearer end lies our own British soil on which landed the first missionaries taught and inspired by Martin of Tours. On this bridge, Martin was uniquely trained for the kingdom of heaven and its later establishment in Gaul and beyond. He was able to bring out 'treasures new and old' from many varied and powerful influences and sources of inspiration. Raised and educated in a pagan family, he had then been taught and inspired by Christians refined in the fires of persecution. He learned unquestioning obedience as a soldier in the Roman army but had also taken the stand of Christian baptism among pagan comrades. The genuineness of his conversion was revealed in the famous story of the sharing of his cloak on a bitter day with a shivering beggar, demonstrating the compassion of his new Master.

Martin served in the Roman army for twenty years before his sudden dramatic departure. This story had hints of the sort of Old Testament confrontations we read of concerning David and Goliath or Elijah and the prophets of Baal. Accused of cowardice on requesting to leave the army before a forthcoming battle, Martin offered to face the enemy unarmed. Next day, instead of the expected bloody battle, the barbarian army inexplicably

surrendered! Perhaps this mysterious event was noised abroad in Gaul long before Martin arrived as that country's apostle.

In the years following his army service, Martin was brought under the transforming influence of those who had literally left all to follow Jesus. This was the age of the desert fathers and mothers, the first of whom may have fled from persecution and taxes. But among them were some, like Anthony and Pachomius, who had found in the Upper Nile Valley such freedom from pressures and temptations that they chose to stay, devoting themselves to prayer and an ascetic, self-sufficient life. So many believers sought them out for teaching that the first simple monastic communities were formed there in the desert. It was the great Athanasius, Bishop of Alexandria, who made these small, isolated communities known, to Martin among others, through his *Life of St. Anthony.*

Martin now longed for such simplicity and seclusion. He sought out for guidance and counsel that great champion of the faith Hilary in Poitiers who, though a bishop, lived with his family in almost monastic simplicity. Recognising Martin's exceptional gifts, Hilary made him deacon, and wished also to ordain him presbyter and to leave many responsibilities in his capable hands. Hilary himself was reluctantly leaving for Asia Minor, banished in punishment for his vigorous contest against the Arians (increasingly powerful heretics who denied the eternal Sonship of Christ).

Instead of disaster, his exile proved productive for both Hilary and indirectly for Martin, even as the persecuted Joseph exiled in Egypt centuries before had been able to declare at last, 'God has made me fruitful in the land of my affliction.'[2] From Hilary on his return from exile four years later, Martin was to learn of a different, compassionate form of monasticism practised by Basil in Asia Minor, whose asceticism was expressed in selfless care for the poor and needy, where children were educated, and the sick cared for by dedicated nuns.

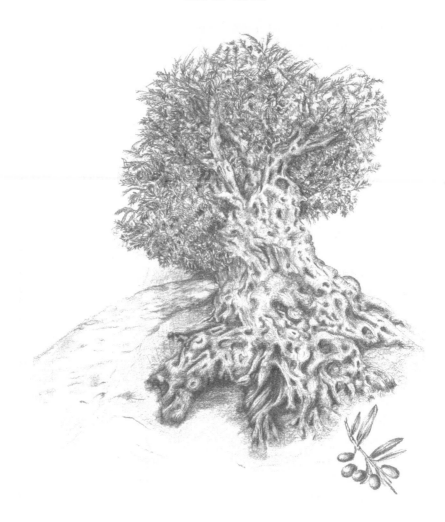

These rich threads of experience and learning were gradually being woven into the pattern of life and ministry which would finally find full expression, and exert such a far-reaching influence, in the monastic community Martin later founded in Marmoutier, Gaul. At times during the previous decade, Martin had achieved his heart's desire, free to live a quiet life of prayer in community with a few disciples in simple dwellings and caves in rural Ligugé. But his spiritual power had become known, and in 371, he was literally dragged to Tours and reluctantly installed as Bishop. Quickly rejecting the trappings of episcopacy, he retreated to a

cliff-face on the banks of the Loire outside the city, there building a small hut from which he would travel to minister throughout the region, but where he could also live again in frugal simplicity and prayer. Disciples with the same hunger and devotion gathered to him in nearby huts or enlarged caves in the cliffs – and so the Muinntir, Celtic for Big Family, was born.

* * *

What is a family? First and foremost, it is a unit built upon layers of generations. As Martin listened and learned from others, gradually discerning the pattern for his own life, so listening and learning from the past will greatly enrich our own and our children's lives.

As a family we were blessed with long summer holidays in Jersey, my birthplace. Warm sand under our feet, exploring rock-pools and caves and swimming in the sparkling sea will be lasting memories for the children. But so also will be the times spent with grandparents and on the farms of great-aunts and uncles, learning of ways and lifestyles different from their own in an English city. One favourite activity, especially for our daughters, was to bring out my mother's old photo albums and sit with her, asking endless questions about 'time past' as older Jersey people say. Her memory stretched back through the years of the twentieth century when the even tenor of island life changed little until the Second World War. Her stories were of the farm where all the children helped in the potato and tomato seasons, of long walks through country lanes to town for shopping or to church, of hard work but also of bike rides and dances, both work and activities shaped by the seasons and the weather.

They were awed too by my father's description of his own father's experiences in the First World War trenches of France, and of the later Depression which brought him from his parents and siblings in Hampshire to seek work in Jersey. A romantic story would then unfold as they heard how he met and wooed my mother!

A happy family life suddenly disrupted as war again broke out, engulfing them and their peaceful island. This was living history, learned by our children from their own grandparents' experiences. Old people can be the best tellers of recent history to our children – but we also have rich resources all around us in castles and cathedrals and historical remains. Our history told in these places can prove much more memorable than that taught in the classroom!

On a family holiday in Kent one spring, we visited Canterbury and, after touring the magnificent cathedral, stumbled across little St. Martin's Church. There we found a very long 'bridge' linking us to our early past! We were amazed to discover the church's fascinating history stretching back to Roman times, and the children quickly shared the sense of excitement. In one afternoon, they saw and touched the stones and tiles of the original Roman building which had probably been a pagan shrine, and then learned the lovely story of Kent's Christian Queen Bertha. She had prayed alone in the midst of a pagan court for thirty years – finally seeing the thrilling answer to her prayers in the arrival from Rome of St. Augustine in 597. There followed the conversion of her husband, King Egbert, and of many in the land of Kent. A little stone Christian church was then built, possibly on the site of an earlier, simple wooden structure – in turn replacing the former heathen temple. There Christians are still worshipping today. We have a photo of our nine-year-old standing by the font of possibly Saxon origin, Roman tiles visible in the wall behind. She still remembers the visit and the story!

For children in our present multi-cultural, multi-faith and increasingly secular society, it is vital that they know their history. They need to know and appreciate the history and culture of those who have emigrated here from other lands. But it is of prime importance that they know that the Christian faith was not imposed in this land but was lived and taught by brave men and women, in many areas being welcomed as good news by ancient Britons, even gradually by warlike Angles and Saxons and eventually too by the fierce invading Vikings. Through the wise

Christian kingship of Alfred in the ninth century, it brought a large measure of peace to the land and of education to many. They need to know that Christianity has been the bedrock of our laws and our democracy and that it inspired our first schools and hospitals and much of Europe's most marvellous art and music. Schools will not always teach such things now, but parents can. Visits to such places as St. Martin's Canterbury, and many others, can be both informative and exciting.

Our children still remember more about Roman Britain through visits to Hardknott Pass and to Hadrian's Wall – probably more memorable because of the icy gale which almost blew us off our feet in that wild spot – than from school lessons. While visiting grandparents in Battle, Sussex, we walked over Senlac fields, saw the spot where Harold fell and imagined together the epic battle between William and Harold and their forces in 1066 which changed the course of our history and the shape of our country, particularly in the building of many of our magnificent cathedrals and churches.

Such places make history visible and touchable. And as children learn, in the pick-and-mix confusion which surrounds them today, that our beliefs and values have flowed down to us, more or less faithfully, from our Christian heritage, they can be helped to discern the true from the false in today's world.

* * *

When Jesus' disciples, children among them, welcomed him into Jerusalem, crying out 'Blessed is the king who comes in the name of the Lord' the Pharisees rebuked them. But Jesus replied that if they kept quiet the very stones would shout out.[3] He must be made known! He must be praised!

We have a vivid example of 'stones crying out' in Old Testament times. In the story of Joshua's leading of the people of Israel into the Promised Land, we find them encamped on the eastern bank

of the River Jordan. The full-flowing river must have looked as insuperable a barrier to the Israelites' progress as the Red Sea had appeared to their fathers forty years before. Did their history help them to believe now? Or did they look on in amazed unbelief when Joshua commanded the priests to carry the Ark of the Covenant right into the waters of the Jordan? They needed to get their feet wet before the promised deliverance from God was given. Then the river stopped flowing, dammed upstream at Adam, and the awed Israelites walked across into their land of promise, followed by the priests and the Ark.

As they reached the farther bank, the waters tumbled down their course again – but not before twelve strong men had lifted twelve great stones from the riverbed. At God's command, they carried them on their shoulders to Gilgal, between the river and Jericho. Their purpose? It was a clear command from the Lord: 'So that this may be a sign among you. When your children ask in time to come, "What do these stones mean to you?" then you shall tell them that the waters of the Jordan were cut off in front of the ark of the covenant of the Lord. ... So these stones shall be to the Israelites a memorial for ever.'[4]

Here we see children, naturally inquisitive, wanting to know what the world around them 'means'. And we see God's desire that they should know and his clear command that we should tell them. 'Why? Why?' children ask. These answers, these stories, will thrill them. But most importantly they will hear that the Lord did this 'so that all the peoples of the earth might know that the hand of the Lord is mighty and so that you might fear the Lord your God for ever'.[5] For this reason, we must still 'explain the stones' to our children.

To visit:

*Local castles, churches, cathedrals, battlefields with children and grandchildren, and tell their stories on the spot!

*Older members of the family or friends, to dig out old photos and ask about early memories, their homes, work, play, school, and what their lives were like.

Notes

1 Christopher Donaldson *Martin of Tours: The Shaping of Celtic Spirituality* (Canterbury Press) Preface p ix
2 Genesis 41:52 RSV
3 Luke 19:38,40 NRSV
4 Joshua 4:4–7 NRSV
5 Joshua 4:24 NRSV

CHAPTER 5

ST. DAVID

THE LEVEL OF THE ORDINARY

Twenty people were expected for lunch, and the kitchen was buzzing with activity and last-minute instructions for the student helpers. 'Would you wash the lettuce please?' and to another, 'Please prepare this cucumber.' Plates of food were ready, and salad bowls were waiting for their mix of lettuce and herbs to be dressed. But one student, knife in hand, was still looking helplessly at the cucumber. 'What do you mean? What do I do?' While the other viewed in dismay a bowlful of soggy green sludge, the lettuce she had just washed in hot soapy water.

We were in L'Abri, a 20th-century Christian community which welcomed people from all over the world who wanted to study to discover whether Christianity was true. Most studied for half the day and helped in the family homes which formed the community for the other half – in the gardens and kitchens, with ironing and bed-making. This ordinary work was familiar to some but a revelation for many more, especially those from large American cities. 'You make cakes from scratch?' was a wondering question as eggs and fat and flour and sugar were beaten together, 'Not from a packet?' To see pizzas made instead of bought in a box, to smell baking bread, to get hands dirty in the garden with soil under broken fingernails – proved to be a journey of discovery for many, often delightful, sometimes unwelcome.

The reason for this half-and-half programme was not only practical, a means of getting necessary daily work done. It was an introduction to the ordinary, to the raw materials of life placed all

around us by our Creator and needing our work and co-operation. It was an opportunity to develop an appreciation for all that God has made and to gain new skills in working with it.

* * *

The community which gathered around David in 6th-century Wales had a harsher introduction to basic life skills – they had to pull their own ploughs! David himself was not exactly a son of the soil. His father was Sandde, who was king, with his brother, of

Cardiganshire, and who later became a cleric. His mother Nonne, who became a nun later in life, was also highly-born and is believed to have given birth to David in AD 500.

The account of David's life as told by the Norman Rhygyfarch in the late 11th century was claimed to be based on early records, though some stories are disputable. However, there is no doubt that David was well-educated. He may have benefited from the teaching and excellent library at Candida Casa, either directly through Ninian's successors or through teachers who had trained there. It is known that he sat under Illtud, the father of the Celtic saints in Wales and called 'the most learned of all the Britons' at the monastery he had founded at Llantwit Major in Glamorgan, which was almost a university of its times. Here, as well as the study of the Scriptures, David's broad education included philosophy, poetry, art and arithmetic.

So, it was as one of the most learned men of his time that David dug and ploughed and sowed and harvested, together with those who joined him, to found the little community at Menevia on the farthest western shores of Britain, later to become St. David's. They lived an extremely simple life, far more austere than most communities, then or later. It seems that they were totally self-sufficient in shelter, food and clothing, building simple huts, wearing skin garments, eating only vegetables and herbs and drinking only water. They kept bees, so honey would have been their one taste of sweetness. But this pared-down life enabled them to focus on worship and prayer, itinerant preaching of the faith and generous ministry to the poor and needy. An additional advantage was that if any pirates should approach their coast intent on plunder, there was nothing of value to steal!

Even in David's lifetime, the austerity of the life of his monastery drew criticism. The historian Gildas feared that 'they gave preference to fasting over love' and affirmed 'better are they who preserve a clean heart than those who eat no flesh.'[1] Few would disagree with Gildas's priorities. But David arguably became

the best-loved in his own country of all our patron saints, and something of his influence and lifestyle permeated the consciousness of many later generations. Now, when visiting that part of Pembrokeshire, it is still possible to step back in imagination and see him there. The wild coast has not changed beyond recognition from his day. St. David's itself, the smallest city in Britain, and reached after driving through quiet rolling hills, seems far removed from the hustle and stress of much of the rest of the country. Even now, his story has power. The way his community lived on that stretch of wild coast, sustaining themselves and many poor and needy people by the work of their own hands, while still studying, copying and teaching the Scriptures and giving themselves to worship and prayer, thrusts an uncomfortable challenge at our indulgent, possession-encumbered lives.

* * *

It would be easy to dismiss St. David's life as though we live now on a different planet. But we share the same humanity and live in the same material world made by the same God. Perhaps it was the monks' soil-grimed hands and aching backs which made them acceptable to their listeners and gave credence to their message. Certainly, they must have understood times and seasons and the work of sowing and reaping, building and cooking as well as their hearers did, enabling them to speak the same language as readily as Jesus himself did in his parables.

David's ministry extended into England and across to Brittany, founding many churches before his death in AD 589. But what is noteworthy is that, while most of David's words are lost, his life still speaks. The same is true of many others, such as St Teresa of Calcutta. Her words are sometimes quoted, but it is her extreme simplicity of life and selfless, persistent love for the poorest and most wretched, expressed in menial work for them, which still resonates around the world, inspiring many others to more caring lives.

Also in India, in the far south, Amy Carmichael of Dohnavur is remembered chiefly for her work among children. But to establish it, she had to make some hard choices. She says, 'The new work seemed poorer than the old. The district where we had itinerated is twice as large as Wales and twice as populous and calls had come from many parts of the Madras Presidency. Could it be right to turn from ... evangelistic tours, convention meetings and so on to become just nursemaids?'[2] The clear answer to her at that time came from John's gospel where we see the Lord of glory who 'tied a towel around himself' to wash feet.[3] But as the work grew more consuming of time and energy, inner struggles surfaced at times, and she felt very often that 'Jack of all trades and master of none'[4] could be written on her tombstone. How many homemakers have felt the same!

There were Christian critics of her choices, who claimed that it was 'not evangelism' when time and money were given to the upbringing and training of children and even to bricks and mortar in which to house them. Her answer was robust but also reveals something of the struggle within her – as it can be with us today – to recognise that the mundane was also Christ's work: 'Well, one cannot save and then pitchfork souls into heaven ... there are times when I heartily wish we could ... and as for buildings, souls (in India at least) are more or less securely fastened into bodies. Bodies cannot be left to lie about in the open, and as you cannot get the soul out and deal with it separately, you have to take them both together'![5] At last, the question she asked herself was 'Is it the bondservant's business to say which work is large and which is small, which unimportant and which worth doing?'[6] So, the matter was quietly settled for her.

The daily work of Dohnavur, so often entailing heavy building projects, broken nights and workworn hands must have seemed like a kind of 'dying' to all the hopes of wide public work, itinerant evangelism and conventions that others expected of her. But it did indeed lead many thousands into Christ's kingdom. It has also been the inspiration for countless other Christian communities and work, a shining example of the truth of Jesus' words that 'Unless a grain of wheat falls into the earth and dies it remains just a single seed; but if it dies it bears much fruit.'[7]

* * *

It is still an unspoken and often unrecognised assumption, among Christians as well as in the secular world, that manual work is a lesser thing. Much has been made of the occasion in the book of Acts when the apostles decided to leave to others the work of distributing food to widows and the needy so that they would be free to preach. There is no suggestion, however, that Stephen and the others chosen for this work had a lesser or lower role. They also were full of the Holy Spirit and wisdom. The tasks were simply shared. If we look closely at the Scriptures, we do not see

such distinctions. At times when it was necessary to supply his and others' needs, the great evangelist St. Paul readily resumed his trade of tent-making.

One of the most famous men in the Bible is Noah. Those who know little else of the Bible know something of Noah and his ark and the animals. It is said of him that 'he found favour in the eyes of the Lord. He was a righteous man, blameless among the people of his time and he walked with God.'[8] Unusually high praise! What was his world-changing, God-given task? Not to preach to the rebellious and wicked around him but to build a boat. And the materials and the measurements and the detailed design were not left to his own guesswork or skill but were given by the master boat-builder, our Creator God.

Moses was commanded to make a tabernacle and the architect here too was none other than God himself – and God also the designer of all the items within it, both useful and artistic. 'Make this tabernacle and all its furnishings exactly like the pattern I will show you.'[9] After the detailed pattern was given, men were chosen. We still have their names – Bezalel and Oholiab! We know nothing about them except that they were chosen by God to be 'filled with the Spirit of God, with skill, ability and knowledge in all kinds of crafts.'[10] The same Spirit of God who inspired the great and famous prophets filled these unknown men to create with their hands something for God's glory.

We therefore see, in the earliest books in the Bible, our God as architect and builder and even tailor! For, as Adam and Eve were banished from the garden of intimate fellowship with him, God 'made garments of skin for Adam and his wife and clothed them.'[11]

'The edge of glory is found at the level of the ordinary.' This conviction gained from the Scriptures was passed down from our Celtic forebears and seems to have stayed for centuries in the consciousness of the Celtic races.

In the 19ᵗʰ century a Scottish scholar named Alexander Carmichael lived for 40 years among the people of the Outer Hebrides and Highlands of Scotland. He walked and talked with them, gleaning from them the prayers and poems which had been part of their lives for generations. His poetic, sensitive translations from the Gaelic of these oral traditions are collected in his Carmina Gadelica. Here we find prayer and praise and affirmations of trust breathed into every ordinary task at home, in the field or on a journey, from rising and washing and dressing at dawn to the smothering of the fire and lying down to sleep at night.

'O great God, aid thou my soul,
With the aiding of thine own mercy;
Even as I clothe my body with wool
Cover thou my soul with the shadow of thy wing'[12]

As everyday acts of dressing and working with one's hands are simply and naturally offered to God, the thought then easily moves on to things of the spirit and to our relationships with others.

'I will kindle my fire this morning
In the presence of the holy angels of heaven ...
God kindle thou in my heart within
A flame of love to my neighbour,
To my foe, to my friend, to my kindred all ...'[13]

This seamless weaving together of work and prayer seems to flow directly from the belief and practice of the Celtic monasteries. In neither do we find a hint of dissonance between the two. In neither do we find a hint of any sense of inferiority of one compared with the other. In the prayers of the islanders, we find solid, unaffected trust that God is involved in the grinding of corn, milking of cows, weaving of cloth or building of fires. There is, therefore, great significance in these tasks. They are of value for their own sake, in the awareness that Christ himself was a carpenter, made fires, cooked fish, washed feet. This awareness elevates all tasks far

above the level of 'drudgery', hard though they may sometimes be – and certainly often were in Highland crofts and the storm-swept islands of the Outer Hebrides.

* * *

For most of us today, daily work will be vastly different from theirs. It is probably indoors, insulated from cold and wet and surrounded by people and noise rather than quiet open spaces. We are far more likely to work with computers or machines than with animals or raw materials. However, the understanding that 'without him (Jesus) nothing was made that has been made' shines light on every aspect of this work too. As the crofters could pray as they worked 'Bless O God my little cow ... and the milking of my hands'[14] or 'Bless, O Chief of generous Chiefs, My loom and everything a-near me'[15] so we can recognise the Lord's presence in our workshops or offices, schools or hospitals and ask his guidance and blessing on all that our hands do, with tools, pots and pans, pens, instruments and computer keyboards. All is covered in the simple old Celtic prayer *'Bless to me, O God, my heart and my speech, And bless to me, O God, the handling of my hand.'*[16]

The eldest of our children was working towards his Technology GCE. He had designed and built a sound-activated device for partially sighted people. It was in two parts and, the day before it was to be handed in, the two parts worked perfectly separately but completely failed to work together. Stress was building. He examined every wire and every connection; no fault could be found. Late in the evening, I was wearily holding bits of the project for him and trying to pray over it as he tested it all again. Suddenly the promise came to mind, quite out of the blue and out of context. 'All things *work together* for good to those who love God.'[17] These bits were working separately – but not together! In tired simplicity, the prayer came, 'Thank you, Lord! May we ask you please to make even this project *work together*.' Soon afterwards it did. And the project was successful. Not all our prayers are answered so obviously and immediately, and we sometimes learn even more

from trusting and waiting. But this experience was remembered and served to build faith for far more demanding electronic projects and other challenges in his later career.

* * *

In David's monastery, as in Martin's and Ninian's, the day's work was punctuated by united times of prayer and praise in the chapel. However, all their work, whether writing or fishing, sewing their own clothes or building walls was done in the consciousness of the presence of God and in a prayerful spirit of co-operation in God's creative work.

Echoes of these earliest prayers can be heard in some of those told and sung to Alexander Carmichael many centuries later, passed down by oral tradition through generations of people who lived on the same land. Others have been adulterated, some mixed with superstitious beliefs. But in many, we find a remarkable natural dignity and poetry in people who would have lacked much formal education. Like the first disciples themselves and the earliest Celtic Christians, their awareness of God and belief in his presence and word informed their minds and lives in a way which lifted them, gave significance to them and hallowed the lowliest tasks.

It seems in our society today that the lowliest tasks are deemed to be the care of the youngest and the oldest in our communities,

judging by the wages paid and value given to those who provide this care, and also sometimes by the rare, sad stories told of neglect and even mistreatment. A sudden and unexpected spotlight has been shone on such work by the shock of the Covid-19 pandemic. Unprecedented attention and respect is now being shown to carers. How transformative would be attitudes to those who give this care and to the bathing and nappy-changing and messy feeding involved in such work at home or in other settings, when the frailest and most helpless are seen as precious to God and our hands as his hands providing his own care for them.

Today there is increasing interest in 'mindfulness', a practice sourced from Buddhist philosophy. In addition to encouraging calming meditation, it promotes paying attention to our senses and being wholly present and attentive in the performance of everyday tasks. This is surely an unrecognised desire for what was once an integral part of our Christian heritage but was then sadly lost, not only in the noisy confusion of the world but also largely in the teaching and practice of the church. In Scotland and the Islands from the Reformation onwards, these ways were suppressed. Then they were almost entirely lost in the traumatic 18th-century clearances of land for large-scale sheep farming throughout the Highlands and Islands when entire crofting communities were destroyed, and thousands of closely connected people displaced and scattered, many to other lands.

The intrinsic value of the work of our hands has also been lost in the present day as practical subjects have dropped out of the school curriculum. Our children, even the most academic ones, once learned cookery, sewing, woodwork and metalwork at school. Gradually these subjects were displaced by theoretical home economics and information technology. As valuable as these are in today's world, our children's development is stunted if they do not learn to use their hands and develop skills which are not only useful but also deeply satisfying; and if these are not taught at school, we need to create opportunities to develop them at home. They can be fun as well as useful; shared cooking or gardening with Mum or

Dad, bits of carpentry during DIY projects, grandparents teaching to fish or sow seeds, to sew or knit – fun, bonding activities that help to build strong family life and develop skills for the future.

Our large Vicarage garden had a big vegetable patch, the length of one side of the house. Like many others, my husband found the work there both satisfying and therapeutic – a time to unwind after work in the study or parish, and the physical work of digging de-stressing. It also provided the children with awareness of where food comes from and all the processes involved from sowing and tending, weeding and harvesting to storing for the winter. Climbing trees to pick fruit was quite good fun but involving them in other messier gardening was a harder task. One inducement that did work, however, was when my husband encouraged the younger son to go and help him 'to grow roast potatoes'!

During a visit by both our sons and their families, during which they enjoyed a variety of visits and walks and playgrounds, there suddenly arrived on a rainy day an 'I'm bored' moment for two little boys. Pastry and pots of jam were produced, and they were soon totally absorbed in rolling and cutting out pastry, carefully placing it in patty tins, then spooning jam of different kinds and colours into these small areas. Two active little boys could then be seen crouched on the kitchen floor, engrossed in watching the baking of their jam tarts through the glass oven door. Cooking was then followed naturally by 'numeracy' as they counted the tarts and worked out how many each family member could have as they shared them around! Boredom was banished and a grey afternoon transformed.

* * *

Refusing to be squeezed into the world's mould means, in part, to restore these godly values and skills in our homes. And it all begins with Creation! The big, beautifully-illustrated Children's Bible our first-born was given by his godfather opens with wonderful creation pictures. Before they could understand the words, our children drank in these dramatic illustrations of swirling clouds and emerging

planets, every kind of animal, lush vegetation and the first man and woman; and they learned that 'In the beginning God created' every bit of this marvellously intricate material world - all beautifully-expressed in ways which the youngest and least-educated are able to absorb. Later they will learn of the great age of the universe and of the gradual evolution of the species within it. The relationship between what science has discovered and the truth of God's ownership of all creation can be worked through at home. But if this basic truth becomes part of them in early childhood, all that they learn later will be seen in its light and the natural world and the people in it valued and respected.

The second formative truth gleaned from Genesis is that we are made in God's own likeness – therefore we too are creative. Our creativity comes from him and when we make something with our imagination, our minds and our hands – a chair, a cake, a garden, a painting – we are sharing in his creative activity, we are in some measure doing what he made us to do.

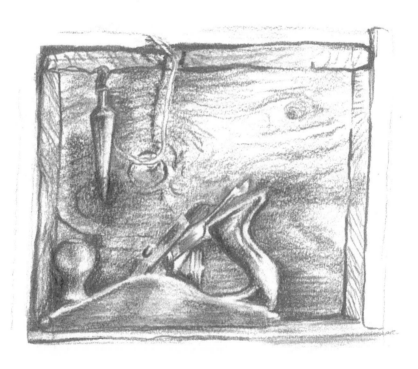

In Jewish synagogue schools, the boys were taught the Torah. But they were also taught a trade. How wise! How understanding of the whole person and of the necessity to develop every part of it because God gave us hands and muscles and imagination as well as brain.

After a life of preaching and teaching, founding churches over a wide area and countering heresy, it might be expected that David's final words to his brothers would have focused on a challenge to continue this great work. But as he closed his final sermon, his words echoed the simplicity of his life: 'Be joyful and keep your faith and your creed and do the little things you have seen me do and heard about.'[18]

The poet and Anglican priest George Herbert understood the significance to God of the ordinary work and small events which make up such a large part of our lives and wrote of it in his lovely poem 'The Elixir', which has been set to music as a hymn.[19] Commenting on his work, the Revd Arthur Middleton, Rector of Borden and Canon of Durham Cathedral has said that his hymns 'have enabled generations of worshippers to bridge the worlds of earth and heaven through a sensitivity that sees the extraordinary in the ordinary.'

The extraordinary can indeed be found in the ordinary tasks at home or work, whether small and hidden, even messy and distasteful, or in the bustle of public life. There we can know God's presence and inspiration, express his love and reveal his glory.

To illustrate and put up in the kitchen or office ... or sing (tune 'Sandys' as in the carol 'A child this day is born')

<u>'The Elixir' by George Herbert</u>

Teach me my God and King
In all things Thee to see
That what I do in anything
To do it as for Thee

All may of Thee partake
Nothing can be so mean
Which with this tincture (for Thy sake)
Will not grow bright and clean

A servant with this clause
Makes drudgery divine
Who sweeps a room, as for Thy laws,
Makes that and the action fine.

This is the famous stone
That turneth all to gold
For that which God doth touch and own
Cannot for less be sold.

To reflect:

'Do small things with great love': St Teresa of Calcutta.

Notes

1 Diana Leatham: *They Built on Rock*: (Hodder and Stoughton) p.91
2 Amy Carmichael: *Gold Cord* (SPCK) p.40
3 John13:4.5 NRSV
4 Amy Carmichael: p.183
5 ibid. p.244
6 ibid. p.40
7 John 12:23 NRSV
8 Genesis 6:9 NIV

9 Exodus 25:9 NIV
10 Exodus 35:30–35 NIV
11 Genesis 3:21 NIV
12 Alexander Carmichael: *Carmina Gadelica* (Floris Books) p.198
13 ibid. p.93
14 ibid. p. 344
15 ibid. p.115
16 ibid. p.197
17 Romans 8:28 NRSV
18 *The Welsh Life of St. David*: ed. by D. Simon Evans (University of Wales Press) p.13
19 English Hymnal no. 485
20 Rev. Arthur Middleton, Rector of Bolden, Hon. Canon of Durham Cathedral *Faith of Our Fathers*

CHAPTER 6

ST. COLUMBA
EXPLAINING THE STONES

It was a warm summer afternoon, usually a time to relish the extra hours between school and tea-time for play in the garden. But our little boy had been unusually quiet and serious on his return from school, and instead of heading for the garden and his favourite rope-ladder on the ash tree, he had disappeared into his bedroom. After a while, I decided to check if all was well and was surprised to meet him on the stairs carrying his big Children's Bible. 'Can you read me the story of Daniel in the lions' den?' he asked.

Sensing that this was a need rather than a whim, I sat with him there on the stairs, the late afternoon sun warming us through the landing window. We read the story – the devious scheming of the presidents and princes which landed Daniel in trouble with the king, the long, fearful night in the den of lions and then of how God had 'shut the lions' mouths' and marvellously protected and cared for him. In the picture, the lions looked quite docile as they snuggled up to Daniel! But it was unmistakeably clear that God had made them so.

It was some time later that we learned of trouble at the local school. It was the first time in living memory that any rector's son had attended the village school and he didn't speak with the local accent. That was enough difference to attract unpleasant teasing and name-calling. A few words with the teacher eventually settled the matter – but in the meantime, one little boy had remembered that Daniel too was 'different', had been given courage from his

example and the faith to believe that God could shut threatening mouths.

* * *

A long time ago, another young boy had a portion of this same book in his hand. It so thrilled and inspired him that he studied it, fought for it, was exiled on its behalf and spent his long years in teaching and preaching it. St. Columba of Iona was born in AD 521 of noble lineage in Ireland, among the mountains and lakes of Donegal. Irish sources tell of his early upbringing by foster-parents whose education of the young boy included not only the necessary hunting and fishing of the area but also daily study of the Latin Scriptures. Among other possible meanings of his name, it is suggested that his nickname 'Columcille' (Colum of the cell) might have been coined by playmates who had to call him out to play from the cell where he studied so keenly with his master. He continued his education at Clonard Abbey in Co. Meath among students, perhaps as many as 3,000, some of whom would become the most significant names in early Irish Christianity. St. Finian was the inspirational teacher under whose tuition Columba became one of the influential 'twelve apostles of Ireland'.

Now a monk and priest, Columba travelled widely, founding monasteries where many others could study his beloved Scriptures, including Derry, Swords and the still-famous Kells, where in a later century equally devoted monks worked tirelessly to copy and illuminate the marvellous Book of Kells. Columba desired above all 'to search all the books that might be good for any soul.'[1] It was this passion that drove him to establish institutions where others could be taught as he had been – but which also led him into the greatest wrong and sorrow of his life.

Manuscripts of the gospels and psalter were rare and precious. But there seems to have been a very good library at Moville, Co. Down. There, in around 560, while studying under St. Finian, Columba copied one of these treasures which Finian so carefully guarded.

Different accounts suggest it was either a psalter or perhaps a manuscript which included the gospels. Certainly, Columba cherished his copy – so much so that he defied Finian, who claimed ownership of it. Passions were aroused, and influential friends and clansmen on both sides joined the increasingly angry dispute. It ended in the bloody battle of Cúl Dreimhne which King Diarmit's forces won for Finian. As punishment for causing such a terrible shedding of blood, Columba was threatened with excommunication. Only the intervention of his friend and fellow 'apostle' St. Brendan of Birr saved him, though the alternative punishment of exile was still dreadful to him.

Deeply chastened and grieving as he left his beloved homeland for Scotland, Columba vowed to gain as many souls there as had been lost in battle in Ireland. Travelling until Ireland was out of sight, with twelve companions, he settled on the island of Iona. And so, another little Christian community was born – a Big Family, like Martin's in Tours, like Ninian's in Whithorn and David's in Minevia. Now they needed to do all the things any family must do to create a home. Shelter and food must first be provided; but through all the building and tilling of land for crops, they would pray and worship and, as soon as possible, study and teach. The few manuscripts of Gospel and Psalter that they had brought with them were copied, laboriously and devotedly, till Columba's volumes numbered over three hundred. Studying these would be at the centre of the life of the community, informing all their other work of teaching, itinerant preaching, farming and fishing. For they also believed as Columbanus insisted, that the Christian life is to be lived, not theorised and debated.[2]

* * *

In Charles Dickens' famous novel *Nicholas Nickleby*, the infamous Mr Wackford Squeers of Dotheboys Hall claimed a similar educational theory! On his first morning in that icy establishment, the newly appointed teacher Nicholas Nickleby watched as Mr Squeers began 'the first class in English spelling and philosophy.'

'We go upon the practical mode of teaching, Nickleby,' Squeers explained. 'C-l-e-a-n, clean, verb active, to make bright, to scour. W-i-n-d-e-r, winder, a casement. When the boy knows this out of book he goes and does it.'[3] As the first boy cleaned the back parlour window, a second was despatched to work in the garden after being told that 'B-o-t... t-i-n... n-e-y' was a knowledge of plants! This spurious claim to make book-learning practical is both laughable and sad as Dotheboys Hall was a monstrous place of abuse and pretence at a practical education.

A very different mode of both deep study and its practical application was followed by Columba and his monks. It was clearly taken to heart by them, for later Bede was to write admiringly of St. Aidan, trained at Iona, who would take the gospel across to Northumbria. 'The highest recommendation of his teaching to all was that he and his followers lived as they taught he always travelled on foot unless compelled by necessity to ride; and whatever people he met on his walks, whether high or low, he spoke to them he inspired by word and deed to live a good life and be generous to others.'[4] This would be the fruit of study for every Celtic Big Family. It seemed that he also understood good teaching methods. On hearing that an earlier attempt to preach the gospel in Northumbria had met with 'obstinacy', Aidan noted wisely 'It seems to me that you are too severe. You should have followed the practice of the apostles and begun by giving them the milk of simpler teaching, and gradually nourished them with the word of God until they were capable of greater perfection and able to follow the loftier precepts of Christ.'[5] These wise words of Aidan could be helpful to parents!

It is said of the Celtic church that it loved the Old Testament. Here it would find instructions for family life in God's words concerning Abraham, just before the destruction of Sodom and Gomorrah: 'I have chosen him so that he will direct his children and his household after him to keep the way of the Lord by doing what is right and just, so that the Lord will bring about for Abraham what he has promised for him.'[6]

Again and again in the Scriptures, we read that children are to be taught regularly the ways of the Lord and of God's care and guidance for their families in the past. The story of the Israelites' rescue, under Moses, from Egyptian slavery was to be told dramatically every year as the Passover meal was re-enacted. "When you enter the land, God will give you as he promised, observe this ceremony. And when your children ask you, 'What does this ceremony mean to you?' then tell them, 'It is the Passover sacrifice to the Lord, who passed over the houses of the Israelites in Egypt and spared our homes...'[7]

* * *

There is great power in story. Stories are remembered when abstractions and instructions are long forgotten. Just as our six-year-old was emboldened by Daniel, the modelling of other lives, their trials and courage, their rescues or victories can be lodestars for the youngest child.

Fairy Tales provide a start! It is said that many parents today shun them because some are frightening, and others seem politically incorrect. Of course, the age and sensitivity of each child must be carefully considered, but we could miss opportunities to illustrate the difference between cruelty and kindness, justice and injustice and many good values, as well as deprive our children of exciting and wildly imaginative stories if we neglected them. In *Cinderella,* we see a girl treated as a drudge but in no way is her situation held up as a model for females. Instead, it is clear from the story that good people (her fairy godmother and the prince) are needed to rescue her from it. On the contrary, the plans of the greedy, selfish sisters are utterly foiled and theirs is certainly not the path to happiness. The 'ugly duckling' has entered our language as an epithet for someone who seems to begin life with few advantages, but the story must have given hope to many small children, tempted to feel unattractive or inadequate, that their futures might well be brighter. Dwarves feature in *Snow White*, not at all as unnatural or objects of pity; instead, they are hospitable,

welcoming and kind while the rich and vain stepmother, like many present-day celebrities, does not flourish by her bullying and instead comes to an unhappy end. These tales stay in the deep memory where values can be shaped.

Reading to and with our children does not have to end in their early years. *Just William* produced tears of laughter from both my younger son and me at bedtime even when he was a fluent reader himself, simply because it was so much fun. I did know of a theologian's wife who strongly disapproved of Richmal Crompton's William as he told fanciful stories and got into so many scrapes, but not all of our bedtime reading needs to be of the improving sort! We are blessed to have a rich English heritage of both exciting and uplifting stories to introduce to our children and grandchildren. These will be good, nourishing and appealing food for the mind and imagination, with some read just for fun.

Whatever other tales of courage or adventure we may read with our children, the Bible provides us with some of the best. What can compare with young David's battle with bears and lions as he cared for his sheep – training him for his epic defeat of Goliath? Or Samuel's moral courage in telling unwelcome truths to an apparently wise old priest? We have an unnamed servant girl daring to advise her master to go and find healing from leprosy in the land from which she had been abducted. We see Joseph in a family riven by favouritism and jealousy, falsely accused, unjustly treated, yet through severe trials staying faithful, and later raised by God to great power and usefulness. Encouragement for even the littlest and least is found in the story of Jesus taking and blessing one small boy's simple lunch and using it to feed thousands.

These stories, with Jesus' incomparable picture-parables, will soak into mind and memory and help to shape character. They will raise expectations of what can be achieved in life and give confidence to those who, like Moses and Gideon, struggle with a sense of inadequacy. Above all, they will inspire faith that God,

and they themselves, can and will work good into this world's confusion and brokenness.

* * *

That the Celtic saints could have had such vision for the rest of the world seems almost incredible to us. Most journeys in 6th or 7th-century Britain would have been cold, muddy, arduous and dangerous. Even their simple homes must have seemed appealing when faced with the wet and wind and the threat of thieves as they looked beyond their walls. Yet Columba's predecessor Columbanus travelled by sea and over land to Switzerland founding St. Gall's monastery near Lake Constance and to Italy where he is still commemorated in Bobbio for the fine community he established there. For Columba and his monks there were challenges enough in Iona and the still pagan areas on other Hebridean islands, on the Scottish mainland and later back in Ireland. The needs of the world beyond their home were always in their sights.

The sketchy geography taught to our children in many schools seems to leave many gaps. Yet for children to grow up seeing themselves as one part of a huge world family is vital to a sense of perspective and of respect for and responsibility for others. At home, a world map on the wall is a great aid to identifying countries and oceans and cities as they are featured in the news. A lighted globe is even better. But these Celtic Christians saw the world as a place waiting for the kingdom of God – not quite the world view presented by the media of television, internet or newspapers.

During unrest in Egypt before the Arab Spring, it was widely reported that Coptic churches had been burned and Christians attacked, the sort of news likely to provoke indignation and anger against Muslims. However, an event which did not make the national news was featured in a missionary magazine and revealed a much more heartening picture. In protest at this well-publicised attack, thousands of Muslims came later as 'human shields' to

protect the Coptic Christians' Christmas celebrations, saying 'We either live together or we die together'. Millions of Egyptians changed their Facebook profile pictures to the image of a cross within a crescent symbolising an 'Egypt for all'.[8]

Schools which have links of friendship with schools in other countries provide a marvellous opportunity for greater understanding and wider sympathies. Failing this, parents can make sure that our children are exposed to positive news like this example from Egypt. Missionary and Aid magazines are a good source. Stories of people digging wells for needy villages or of food and medical care brought to them can inspire children who often have a ready natural sympathy for those in need. The simple act of filling a shoebox and finding out where it is heading can be both exciting and rewarding for the youngest child.

Such involvement with other, less-advantaged lives abroad can have a lasting impact. A group of young people at our church who met weekly for fun, friendship and Christian teaching seemed ready to be introduced to others in needier circumstances. This happened to be the time when Communism was losing its grip in Eastern Europe and we all awoke to the news of dire conditions of many repressed communities – most shockingly, of Romanian orphanages. The images of sad, neglected children on TV screens moved all ages, including these young people. I knew people who travelled regularly to these countries bringing help and support. Could our young people do something? Would they like to? Most of them were from non-churchgoing families, some had made a Christian commitment, others were interested and on the fringes of faith, while others were coming just for the fun. But the leaders had never experienced such an immediate, wholehearted response to any suggestion. Contact was quickly established with young people in a Transylvanian church who had some knowledge of English. Letters began to flow between the two groups, and we identified needs that could be met by our own young people. First, the Romanian people wanted Bibles. A piggy bank was put out with the tuck shop. Sometimes spare change was put in, more

often the snacks and sweets were ignored, and they dropped all their tuck money into the piggy bank and went carol-singing to earn more. Soon we were able to send the needed Bibles, followed by English tuition books through the help of a generous publishing house in the city.

Older people in the church were intrigued. Could they join in? Women started knitting, everyone began collecting dried and tinned food, clothes and toys and soon boxes of goods were sent on a regular basis. A young woman in the Transylvanian church became our conduit for these gifts, channelling them to the poorest families in the area and to a kindergarten for disabled children, previously sadly neglected. The burst of teenage enthusiasm for letter-writing soon waned! One exception was our elder daughter who continued the correspondence right through university years, building a friendship which later led to valuable and happy visits to and from Romania. But for all, as photos arrived of the boxes of goods being opened and of thin little children clutching the toys sent by our own young people, a pattern of sympathy for others and a realisation that they could do something in this world that makes a difference became rooted in minds and lives.

Another amazing realisation was also dawning. We were teaching stories from the Bible which spoke of God's help to those in need. Would God really act in answer to their needs and prayers too? We had no ready-made means of transport for any of the goods we wanted to send. On each occasion, everyone was urged to pray that a way would be found. The ways found were various, usually surprising and often last-minute, delighting these teenagers with the growing awareness that no problem was too big or too small for God's care and that he did indeed answer their prayers too.

* * *

It seems that heaven shares this delight. We learn from Jesus' own mouth that there is rejoicing there when a lost person is found.

One cannot imagine rejoicing without smiles or even laughter! As a family, we suspected that there were smiles in heaven over a far less significant event than the one in Jesus' parable but still a very special answer to prayer for us and the children. After a very busy time, we were keenly looking forward to our family summer holiday. Arrangements had been made for the care of the parish and the house, the ferry to Jersey was booked, and bags were being packed. However, rumblings of discontent among the ferry seamen were growing until finally a strike was announced. All sailings were cancelled. Days of talks went by without any sign of a resolution. Both sides seemed immovable. On the day before our holiday was due to begin, the news bulletins gave no hope. The talks were deadlocked.

We were praying, the children were praying, and a surprising sense grew that we should do as the children of Israel had been told to do at the Passover – get ready and, in spite of all evidence to the contrary, be totally prepared for departure. The drive to Weymouth would take us five hours, so any hopes of catching a lunchtime ferry next day seemed completely out of the question. However, on Sunday evening, the packed bags were piled in the hall. At bedtime, we listened to the late news. It was as depressing as ever.

A night-time cat fight in the garden was not very uncommon but was usually settled quickly by the most aggressive feline! But on that Sunday night, it was ear-piercing – and it went on and on, right under our open bedroom window. Finally, my husband got up to fetch a mug of water, and his aim must have been accurate as the cats squealed and dispersed. Now reluctantly wide awake, we decided on a cup of tea. As he brought it back to the bedroom, he turned on the radio. The 5am news bulletin was just starting. It announced that talks between seamen and management had continued throughout the night. Agreement had just been reached. The strike was over, and sailings would resume immediately! Sleepy children were roused, dressed and breakfasted, last-minute clearing up was done, the car was packed, and soon we were

gratefully on the road to Weymouth and our Jersey holiday. To arrange for – or at least allow! – fighting cats as an answer to our prayers certainly caused us to smile. We and the children gave delighted thanks. And they gained an awed glimpse of God's own delight in blessing his children.

Teaching God's ways through the Bible, praying to a Lord intimately concerned in the great and small things of our lives and reaching out to the spiritual and practical needs of others – these were marks of Columba's community in Iona to which, even in a far more modest way, the most ordinary home and family can aspire.

In the last days of Columba's long life, he was still working hard transcribing the Psalter. On the day of his death his strength began to fail just as he was writing 'But they that seek the Lord shall not want any good thing' – leaving his beloved fellow-monk Baithene to continue the next verse, words which could summarise Columba's life:

'*Come ye children hearken unto me; I will teach you the fear of the Lord.*'[9]

Columba's passion can be ours as we find every creative and loving way possible to teach our children 'the fear of the Lord'.

To do

Hang a world map in the living room or child's bedroom – or better, have a world globe in a prominent place.

To read with children:

Some tried and tested suggestions:

Project World: Open Door
The *Narnia* books: C.S. Lewis

The *Curdie* stories and *Back of the North Wind*: George Macdonald
The Wind in the Willows: Kenneth Graham
The Silver Sword: Ian Seraillier
The Children of the New Forest: Captain Marryat
The Small Woman: Alan Burgess
The Secret Garden: Frances Hodgson Burnett
Mary Jones and her Bible: Mary Ropes.
Pilgrim's Progress: John Bunyan (a children's version for younger ones)
Great Expectations; *The Christmas Carol*: Charles Dickens
The *Just William* books: Richmal Crompton

Other books by Charles Dickens – with judicious editing or summarising of long descriptions.

Some missionary societies publish books for children. Hunt these out to share positive news and exciting stories of events in other countries.

Add more and ask friends for their favourites!

Notes

1 D. Leatham: *They Built on Rock* .p.134
2 Elizabeth Culling: *What is Celtic Christianity/*? Grove Books Ltd.
3 Charles Dickens: *Nicholas Nickleby* .Penguin Classics p.104
4 Bede: *Ecclesiastical History of the English People* p.150
5 ibid.p.151
6 Genesis 18:19 NRSV
7 Exodus 12:25–27 NRSV
8 WEC Worldwide Magazine Spring/Summer 2011:p.7
9 D. Leatham: *They Built on Rock*; p.152

CHAPTER 7

ST. CUTHBERT

THIS WORLD IS NEWS OF GOD!

Standing in the icy waters of the North Sea, a godly man named Cuthbert spent long, cold hours of the night pouring out earnest prayers for his countrymen and singing praises to God to the sound of the waves. The cold and solitude were not unfamiliar to a man who, though well-born, had spent many nights on lonely Northumbrian hillsides while tending sheep. Like the shepherd-psalmist David, he had lived so close to nature that he was physically hardened and was so at ease within God's natural world that it held no terrors for him.

Early on this cold morning, a young monk, concerned for his master's welfare, came quietly along the beach towards him and was rewarded by an amazing sight. As Cuthbert stepped out of the cold sea, two otters followed him onto the shore then lay close to his feet, warming them with their breath and drying them with their fur. When they had finished serving him in this way, they slipped back into the sea with Cuthbert's blessing following them.

Such lovely tales as this are usually dismissed as legends now, charming but of doubtful validity and with little practical connection to our lives. However, there are so many references to ministry by animals and birds in the lives of these Celtic saints that it might be worth looking at them more closely with open minds.

The age in which they lived ensured that everyone's daily existence was more or less close to nature. Even the very few wealthy and

privileged who lived in well-built houses were exposed to the elements in ways which we would find extremely uncomfortable. Everyone knew what driving rain and icy winds felt like as well as hunger and unrelieved pain and illness. Certainly, they were well aware of every season, their daily dependence on what the earth produced and of the hard toil needed in gaining it.

While still in pagan ignorance, the people of these lands viewed the natural world as an alien and frightening place. Dearth, disease and death were common, so the malign spirits dwelling in hills and trees and streams must be appeased, sometimes even through human sacrifice, to avoid bad harvests, plague or other disasters. The contrast of the Christian message, telling of a mighty and merciful Creator who loves his world and all people in it, must have been good news indeed to those who could receive it. In Patrick's 'Confession' he speaks of Christ as Redemptor and his teaching was of 'the God of heaven and earth, of sea and river, of sun and moon and stars, of the lofty mountain and the lowly valley, the God above heaven, the God in heaven, the God under heaven.'[1]

So, it is not surprising that a catechism attributed to Ninian of Whithorn claimed that the fruit of study was 'to perceive the eternal word of God reflected in every plant and insect, every bird and animal, and every man and woman.'[2] The study of the Scriptures was central to their lives, but they were also, by both nature and education, open to see and hear God in his creation.

Cuthbert was born an Anglo-Saxon, in Northumbria in about 634, but his spiritual rebirth while still young was into the Celtic church. Christian Britons had been swept back by fierce pagan Anglo-Saxons into the west, to Wales, Cornwall and Ireland. But the spiritual tide turned when Oswald became King of Northumbria.

During political upheaval, Oswald, nephew of the Northumbrian King Edwin, had taken refuge on the western island of Iona, had

been cared for and taught there by good Christian teachers and was ready to do battle to wrest Northumbria from the pagan Penda, ruler of Mercia who had slain King Edwin and taken his land. Inspired by Oswald's vigorous faith, his small army regained Northumbria and Oswald ascended the throne in 635, establishing his capital in Bamburgh.

One of Oswald's first acts was to send to his friends in Iona for a bishop 'by whose teaching and ministry the English people over whom he ruled might receive the blessings of the Christian faith and the sacraments.'[3] Bishop Aidan arrived, and there began a most unusual alliance in Christian evangelism – the humble, saintly Aidan traversing the vast, rugged tracts of Northumbria on foot, preaching and serving the people, frequently supported by the king himself who, in fact, often interpreted for Aidan as he had learned the Scottish tongue while in Iona, whereas Aidan was not yet skilful in English.

Aidan's Scotic monks were established on the small island of Lindisfarne, conveniently near Bamburgh. They quickly mastered the new language and, ministering with Aidan, soon saw the faith spreading over the land. In fact, it was claimed by Bishop Lightfoot that 'St. Augustine was the Apostle of Kent, but Aidan was the Apostle of England.'[4]

Cuthbert was, therefore, able to grow up in a largely Christian environment and was described by Bede as one who 'often prayed to the Lord when surrounded by difficulties and was worthy to be defended by angelic help.'[5] He could meditate and pray while watching his sheep on the quiet hills near Melrose. It was there, while only seventeen, that he heard the call to give his life to Christ's service. Bede tells us that 'he suddenly saw a stream of light from the sky breaking in upon the darkness of the long night. In the midst of this, the choir of the heavenly host descended to earth and, taking with them without delay a soul of exceeding brightness, returned to their heavenly home.'[6]

Next morning, Cuthbert heard that Aidan of Lindisfarne had died at the hour of his vision. Immediately delivering the sheep to their owner, Cuthbert obeyed the call he was sure had come from God and joined the monastery at Melrose to sit at the feet of Boisil, the priest and monk who became his beloved tutor. The monastery was built in a lovely, peaceful location on a bend of the River Tweed, so here Cuthbert could indeed study both the Scriptures and 'the eternal word of God reflected in nature' as advocated in Ninian's catechism.

* * *

The pre-eminent importance of studying the Scriptures was rediscovered in the Reformation. However, somehow over the centuries, the ability for God's people to see and hear him in his creation was to some extent lost. In parts of the very islands where these truths had flourished, although real piety continued, there developed a severe simplicity of worship, which in some measure excluded the beauty of both God's creation and of human creativity.

However, it was in one of these islands that I experienced an example of the Lord's delight in blessing his creation and our handling of it. I was invited to the wedding of two young people in the Inner Hebrides. The groom had lived abroad for several years, where he had met his bride while working for a charity, so was a little out of touch with the customs of his family's chapel. They needed to plan a simple and inexpensive wedding, and they asked me to help by arranging the flowers. Glad to agree, I arrived to find bucketfuls of beautiful flowers just shipped across from Glasgow and ready to be arranged next morning. However, as I looked into the chapel, not a vase or container of any kind could be seen. I learned to my dismay that neither flowers nor hymns were ever part of that chapel's worship. We had beautiful flowers of God's creation with no means of arranging them and a sense that they might be unwelcome, a groom still typing up the service sheets and a bride making last-minute adjustments to her dress. A phone call home asked urgently for prayer!

Next morning, from the groom's family farm, I declined one small inadequate vase and an ice-cream tub offered to me as containers for these lovely flowers. Still quietly asking their and our Creator for help, I walked again towards the chapel. Stopping at the village hall to check on the flowers, I saw that kind friends from the area were bustling to and fro arranging platters of food for the reception. They were far too busy to be interrupted, but one with a kindly face stopped and smiled at the stranger. I explained the predicament. 'Would the flower stands from my daughter's wedding at the village church last month be of any use?' she asked. Would they!

The obstacles quickly crumbled away as help flowed in. This kind lady left her work, drove several miles to collect the flower stands and a large woven basket, then took them and me and the buckets of flowers to the chapel. As I happily filled the containers for the front of the chapel and the basket for the entrance, the perfume from the lilies filled the small building as the sun warmed them. But then a dour face looked around the door. 'We don't have flowers here,' a stern voice told me. Fortunately, I had extracted reluctant permission from the pastor (with his firm warning of 'nothing ostentatious mind!') and was able to relay this to the sceptical elder.

The wedding was lovely, with the singing of simple, unaccompanied metrical psalms and a piper at the door whose music echoed from the sea to the nearby hills. And it was graced with flowers, which in some measure reflected something of the beauty of the Lord who created them, which he surely delighted in and which he has told us to consider and learn from – and whose help I had experienced in 'the handling of my hands'.

* * *

Cuthbert's faith in the God of both the Bible and his creation became evident early in his life, even before his vision on the Roxburgh Hills. This faith was strengthened by witnessing a scene

69

reminiscent of the disciples' experience in Galilee. He was near the Tyne estuary when he saw some rafts in trouble. Monks from a nearby monastery were in danger of being swept out to sea by the wind, mocked at the same time by unbelieving peasants on shore: 'Let not God raise a finger to help them! They have done away with all the old ways of worship and now nobody knows what to do.'[7] Falling to his knees, Cuthbert prayed for the monks, the wind changed, and they regained the bank and the safety of their monastery, so humbling the onlookers and challenging their unbelief.

After devoting himself to study, prayer and work for several years at Melrose, Cuthbert was sent as guest-master to Ripon monastery for a short time before returning to Melrose, becoming prior after Boisil's death from plague. The two close friends had studied the gospel of John together during the last week of Boisil's life and 'were able to finish the reading so quickly because they dealt only with the simple things of the faith that worketh by love and not deep matters of dispute.'[8] These 'simple things' stayed with Cuthbert. Clearly his new position was not one of privileged comfort, for Bede speaks of him 'searching out those steep, rugged places in the hills which other preachers dreaded to visit because of their poverty and squalor.'[9] Here as he shared and showed the gospel in poor, inhospitable places, he was himself dependent on God's care for his everyday needs.

One day, tired and hungry, he encouraged his young companion saying, 'He who serves God shall never die of hunger.' Then they saw a large bird swoop down into the river and fly to the bank with its prey. 'Run and see what God has sent,' Cuthbert told the lad.[10] He returned with a fish large enough for them to share with both the bird itself and the family who entertained them in the next village. The Old Testament was greatly valued in the Celtic church so Cuthbert would have been well aware of the account of Elijah's need of food and of how God commanded the ravens to bring him a meal. Cuthbert trusted God to be the same in his day. Anglicans and worshippers of other traditions have often said or

sung from the Book of Common Prayer 'as it was in the beginning, is now and ever shall be' but maybe have sometimes viewed these words as poetic rather than as a truth to be relied on today. Extreme need, however, sometimes revives such faith.

* * *

During the later years of the German occupation of the Channel Islands in World War Two, food became very scarce. Hunger was a daily reality for many islanders and, increasingly, for the occupying soldiers as well. Families in St. Helier, less able to grow food than those in the rural parishes, were living on potatoes and swedes cooked at a local bakery, as fuel for homes had also run out. The mother of one family, recovering from major surgery and very weak, was urgently in need of better nourishment. Her husband left on his bike in darkness and pouring rain, praying for help. His wheel hit something on the road, and he stopped to find – a fish! It was wrapped in paper, and as he felt with his hands around the muddy area, he found a second fish. Clearly, these had been dropped by someone and remained unseen in the dark and wet. But they were as gratefully received as a direct gift from God as were Elijah's and Cuthbert's.

In 664 after the Council of Whitby, Cuthbert was sent from Melrose to the monastery of Lindisfarne as its prior. Here he taught and trained his monks but still walked with them for miles to preach and teach in the scattered communities on the mainland. It is usually said that he was searching for quiet and solitude when, two years later, he retreated to the tiny remote island of Inner Farne in the North Sea. If so, it was not escapism. In a small oratory here, he would engage in his most intense work, battling in prayer for the souls of men and women and against all the forces of darkness.

An early 20th-century missionary in the remote south-west mountains of China, tramped and climbed in conditions almost as primitive and lonely as Cuthbert's, up steep mountains and across rivers among wild, indigenous peoples who also feared and

attempted to placate the local demons. After years of toil, when a remarkable transformation had come to thousands of the tribal people, James Fraser said he had concluded that to see people turn wholeheartedly and lastingly to Christ, prayer must come first, second and third. [11]

From what we know of Cuthbert, this was his experience. But prayer was not Cuthbert's only ministry, for people so valued his wisdom that they would brave the rough crossing to the little island to seek his counsel. He built a small guesthouse for visiting monks near the landing-stage, and it was said of them and others that 'no one departed from him without the joys of consolation ... and sorrow of mind accompanied him no more on his departure.'[12]

On the barely six acres of Inner Farne, Cuthbert lived in his simple dwelling surrounded by a wall of turf and rocks as some protection from fierce North Sea winds. His companions were birds, the sound of the sea and the sky above. He found a small spring of fresh water but had no other means of sustenance. Lindisfarne monks brought tools and Cuthbert dug the thin soil and sowed wheat which failed, then barley which thrived. However, the birds enjoyed it too and Cuthbert had to rebuke them, telling them to take only what God allowed them, whereupon they left his barley alone. Ravens did steal his straw thatch but, in atonement towards this good man who treated the wild things as his friends, they then brought him a lump of lard with which he greased the shoes of his visitors. Eider ducks became his special friends and are known to this day as St Cuthbert's ducks.

After ten years on Inner Farne, Cuthbert reluctantly accepted the bishopric of Lindisfarne. This new status affected his lifestyle very little, and Bede records him travelling extensively to preach and minister while sheltering at night under simple booths of branches. However, after two years, he again withdrew to his island, to his solitude with God and the sea and the birds until his death in 687.

* * *

Our Lord has told us to consider the birds of the air as examples of God's care and provision for us. Elijah and Cuthbert suggest that they can also minister to us more directly. One family was alerted to this possibility on a gloomy, wet January day when the mother stood at the window weighed down by problems. A lovely sound prompted her to open the window. There on a nearby tree was a bedraggled blackbird singing his little heart out. Whatever naturalists may say about birdsong being simply territorial, she heard this one as bravely praising God in very uncomfortable circumstances and was challenged to do the same.

On another occasion, she was catching her breath on admission to hospital for a major operation, having spent the week filling fridge and freezer for the family, getting cleaning and laundry up to date and trying to off-load other commitments. Grateful for a quiet corner bed by a window in the long ward, she now turned her thoughts a bit anxiously to the unknown of the next day and tried to steady herself to pray as she looked out. On an opposite roof sat a white dove. As she watched, it swooped across and perched just above her window. 'How lovely,' she thought, 'he could almost be a messenger of peace.' Tempted to dismiss the thought as fanciful, she watched it fly back to the roof opposite, pause for a moment and then return to sit and stay above her window. Now she wonderingly accepted his presence and the peace that came with him as gentle gifts from God.

It was God himself who chose the dove to symbolise to us his Holy Spirit. It does seem to have a special peace-giving, reassuring work to do for us. Our children were blessed in growing up with all four grandparents still living and active. When they all died within a few years of each other, their loss was keenly felt. After my father died, our younger daughter, who was especially fond of him, suddenly felt the pain of it. Nothing we said could quite comfort her. As she drove away from this conversation, she wondered why the traffic was barely moving. Then she realised that a funeral cortege was in front of her. She watched the hearse moving slowly along, her thoughts still sad and questioning.

Suddenly two white doves flew down close to the road; they circled the car in front of her which carried the coffin, then circled it again before flying away, high into the sky. Perhaps no one else noticed them. But to her, where words of comfort had not reached her, this simple image did, and she was sure it came from the Lord who alone understood how to meet her need of reassurance of her grandparents' safe homecoming. Some years later, during a very difficult and painful time in her life, white doves alighted or appeared near her again on several occasions, always at moments of acute need of guidance or reassurance.

Most often, God's communication to us is verbal, through his word in the Bible or the words of his people. But in times of great weariness or when words are inadequate, others of his creatures can be his messengers, bringing us news of him. Amy Carmichael speaks of similar experiences, describing them as 'a figure of the true ... one of the invisible things ... being understood by the things that are made.'[13]

Celtic Christians would have felt no surprise at such experiences nor dismissed them as coincidences. They were alive to the presence of God in his created world and attuned to seeing and hearing him there. If such events seem rare, it could be due to our lack of understanding that nature is still his handiwork. If they seem fanciful, it may be because we have forgotten that his Spirit still breathes in all that he has made, and we can see and hear him there if we watch and listen.

Such belief is not pantheism, which identifies 'god' with the forces of nature, trapping him there and denying an almighty, holy transcendent God. Nor is it the secular view of nature without a Creator of much of the modern Green movement, nor has it any connection with a New Age belief in Gaia, an earth-goddess. The holistic, balanced biblical view of the Creator/created relationship is perhaps best expressed by attuned and sensitive poets, from the psalmist who sang: 'The heavens declare the glory of God and the firmament shows his handiwork,'[14] – to Elizabeth Barrett

Browning who perceived that: 'Earth's consumed with heaven
And every common bush afire with God.'[15]

Such an understanding is needed to restore deep reverence for
creation, a sense of responsibility for its care and gratitude for all
God's gifts. Even in his day, Bede recognised our human alienation
from God's created order in his comment: 'And if for the most
part we have lost dominion over the creature it is because we have
neglected to serve the Lord the Creator of all.'[16]

Perhaps no poet has struggled as hard to comprehend the presence
of God in his creation or expressed it as effectively as Gerard
Manley Hopkins. The 19th-century poet-priest believed that the
beauty of the world is incomprehensible except as a manifestation
of God's presence in the essence of all things, which he termed
'inscape'. He saw the purpose of each object's existence as being
perfect self-expression, thus revealing some aspect of the nature of
God who created it. Most movingly, he recorded in his journal for
a day in May 'I don't think I have ever seen anything more
beautiful than the bluebell I've been looking at. I know the beauty
of our Lord by it.'[17]

In 'God's Grandeur' Hopkins perceived that:

'The world is charged with the grandeur of God.
It will flame out like shining from shook foil.'

However, he was not unaware of the ravages affected by fallen
human beings:

'Generations have trod, have trod, have trod;
And all is seared with trade; bleared, smeared with toil.
And wears man's smudge and shares man's smell: the soil
Is bare now, nor can foot feel, being shod.'[18]

Similarly, Cuthbert and the Celtic Christians were no romantics.
They too were acutely aware of pain and ugliness and dearth and

death. But beyond these, they still saw the beauty of the Lord in his creation and heard his voice and opened their hands to receive his gifts, both general and intimately personal, from a loving Father to his children.

Above all, they understood that Christ's redeeming work on the cross was for the whole of creation, that his blood would wash away all despoilment as well as our guilt and that his resurrection heralds the restoration of life and beauty where death and ugliness have reigned. We don't have to wait helplessly for some huge future event to experience something of this. We can recognise glimpses of his beauty, hear his voice and receive his gifts to us here and now as Cuthbert did.

Again, as Gerard Hopkins saw:

'And for all this, nature is never spent.
There lives the dearest freshness deep down things; ...
Because the Holy Ghost over all the bent
World broods with warm breast and with ah! bright wings.'

* * *

Jesus himself told us to consider, to reflect on, the lilies of the field because God himself clothes them. This truth came home in an exceptional way on a summer's day when, during a long car journey, a couple were unusually quiet. As the husband drove, the wife was thinking with deep concern of someone in great trouble, who was struggling over a bad decision now deeply regretted. Her thoughts had turned to the promise that 'the blood of Jesus ... purifies from every sin'.[19] Could this truth be experienced in reality and transform this difficult situation? On turning a corner, a quarry came into view, remembered from other trips for its stark greyness, the hillside gashed and scarred. But on this summer's day, the quarry was transformed. Brilliant self-sown poppies had grown over all the exposed rock-faces, the grey harshness covered under a sea of blood-red flowers, 'beauty for ashes'. She had no

doubt that here a gentle gift had been given, a perfectly-timed visual assurance that this great truth was indeed a present fact in one young person's life.

Such personal experiences of God's touch on our lives through his creation may be comparatively rare, but his giving is continuous, daily and nightly, in every season, generously blessing all our senses through sky and sunshine, trees and birds and insects, water and fruits and flowers – all the richness of nature. Our present lives, so often enclosed by walls and traffic-filled streets and focused on computers and phones, are spent in an artificial environment, in danger of denying our five senses much of what God has provided for us and damaging mental and spiritual health.

In contrast, a renewed awareness of our need to spend time in the natural world, and of its beneficial effect on health has gained momentum through the Covid-19 crisis when so much 'busy-ness' had to cease and a marvellous quiet descended. The very air grew clearer, we could see the stars and hear sweet birdsong. One survivor of weeks of severe illness credited his recovery not only to dedicated care but also – in fact, the turning-point – to the moment of being wheeled into the hospital's tranquil, scented garden. Our 21st-century epidemic of anxiety and depression and PDST needs the healing power of nature. So much of God's goodness is waiting for us there.

As Gerard Hopkins was to express it many centuries after Cuthbert or Bede:

'God's utterance of Himself in Himself is God the Word, outside Himself is the world. This world then is word, expression, *news of God*. Therefore its end, its purport, its meaning, is God and its life or work to name and praise him.'[20]

As we consciously turn off other news and make time to watch and listen there, we will hear instead uplifting, peace-giving, challenging, reassuring and sometimes deeply personal *news of God*.

To do:

A few practical ways to see and hear God's 'news' as a family!

*Go camping together, preferably in tents rather than caravanning, where only a layer of fabric between you and nature allows you to hear hedgehogs snuffling past the tent and crickets in the hedgerows and to awake to birdsong and the soft rustling of grass. Leave all smart phones and iPads behind and learn what quiet sounds like, the music in the trees and the steady rhythm of waves.

*Go foraging. Pick blackberries and blueberries and collect sweet chestnuts. They are all free and speak of God's generous provision in nature.

*Grow things. Sunflower seeds are great fun where there is a garden. Children can sow cress and push beans into little pots to watch them grow on a windowsill even in an upstairs flat ... or mixed lettuce leaves which grow fast and can be eaten when small. Any sowing and planting in the garden can be shared with children and is essential if they are to grow with an awareness of where food comes from and of our vital connection with the natural world. Students need to have plants in their rooms and can take a pot of spring bulbs with them to cheer their often bleak, shared houses. They are unlikely to afford flowers for their rooms, but the local common or waste ground will be covered in a rich variety of grasses, free for the picking!

*In inner cities it is often possible to get involved in guerrilla gardening or to start a community garden on local waste ground.

*In a garden or park, stand still and create a pocket of space and quiet – to look with close attention at flowers, trees or sky, to touch bark and pick up leaves, to smell roses, lavender or rosemary, to let our sensory awareness feed our spirits.

*Alert the children to a fine sunset or rainbow. Stop all activity and stand still and quiet with them for a while, watching the

increasing richness and the gradual fading of glorious colours. Suggest that your children drink in and store up the sight in their memory. Such memory banks can be drawn on in later years and harsher times, a reminder that life can bring beauty and glory as well as trouble and gloom.

Notes

[1] Elizabeth Culling: *What is Celtic Christianity*: Grove Books: p.14
[2] Dana Delap and Northumbrian Community: *Celtic Saints* Pitkin Press: p.3
[3] Bede: p.146
[4] Margaret Gallyon: *The Early Church in Northumbria*: (Terence Dalton): p.33
[5] Ibid. p.191
[6] Bede: *Life of Cuthbert*: (Burns and Oates Ltd.1887): p.21
[7] Ibid. p.18/19
[8] Ibid p.41
[9] Bede: *Ecclesiastical History*: .257
[10] Bede: *Life* p. 56/57
[11] Eileen Crossman: *Mountain Rain*: (Authentic Media Ltd.) Ch. 4
[12] Bede: *Life*: p.97
[13] Amy Carmichael: Gold Cord: p 220
[14] Psalm 19:1 NRSV
[15] Elizabeth Barrett Browning :*Aurora Leigh* bk.7
[16] Bede: *Life*: p.93
[17] Gerard Manley Hopkins: Journal 18 May 'A Selection of his poems and prose' Penguin Poets.p122
[18] Gerard Manley Hopkins: *God's Grandeur*: (Penguin Poets): p.27
[19] 1 John 1:7 NRSV
[20] GMH, retreat notes quoted by John Pick: 'A Hopkins Reader.' Introduction p.13

CHAPTER 8

ST BRIGID

OPEN DOOR AND OPEN HEART

The business of preparing and eating food can seem worlds away from the Christian's obligation of sharing the Gospel. Church teaching and practice over the centuries have tended to put these activities into separate compartments, the latter spiritual and pleasing to God, the first as of far less importance and serving only physical needs.

However, there is a lovely Table Grace attributed to our great English evangelist John Wesley which suggests that he saw things differently. It reveals understanding that the Lord could be present at a meal table and worshipped there and that those sharing the meal, however simple, could also turn their thoughts to the wonderful feasting and fellowship of heaven.

'Be present at our table, Lord:
Be here and everywhere adored.
Thy creatures bless, and grant that we
May feast in paradise with Thee.'[1]

A most attractive-sounding Irish woman named Brigid could have penned these words! She lived eleven centuries before the Wesleys, but although she too travelled and preached energetically, she is best remembered for her generous, open heart, which led her to feed and welcome and clothe many – as well as preach.

Whatever of truth or legend survives concerning Brigid, she sounds a most unusual and delightful person. Her brave,

independent spirit revealed itself even in childhood. She was born in about 453 into a family of mixed background, her father Dubthach a Scotic chief of Leinster and her mother a Pictish slave. This poor woman was sold again, moving to the west of Ireland into the ownership of a druid. There her baby girl was born. The mother taught her child what she herself had heard of the Christian faith and it is believed that she even took her to hear Patrick preach. Her hard life suffered yet another loss as, when Brigid was old enough, her mother had to send her back to her father in Leinster, the child's legal owner. But the seeds of faith she had sown in her little girl had fallen into fertile soil. The religion that grew there was the very practical one exhorted by James: 'The religion which God our Father accepts as pure and faultless is this: to look after orphans and widows in their distress and to keep oneself from being polluted by the world.' He spells out the difference between true and empty faith by supposing a brother or sister to be without clothes or daily food and a believer simply wishing the needy person well but doing nothing, and he asks: 'What is the good of that?'[2]

Orphans, widows, the hungry and ill-clothed must have met her daily but the child Brigid had nothing to give. So, she gave freely of her father's possessions instead. She claimed that in doing this, they were giving to Christ himself. A story is told of a beggar who came for bread and Brigid, realising that he would need more than bread to survive, fetched one of her father's sheep for him. At last, in frustration, her father took her to the King of Leinster, hoping to profit from selling her as a slave. While outside, awaiting their fateful decision, she was approached by a dreadfully disfigured leper. In great pity, Brigid gave him the only thing of value lying beside her in the chariot – her father's treasured sword. Her enraged father would have punished her severely, but she was saved by the King of Leinster intervening on her behalf. As a Christian believer himself, he recognised her great worth and refused to take her as slave, saying, 'Her merit before God is greater than ours.'[3]

There are Kilbrides and Kilbreedies scattered all over Ireland, the names meaning the cells or churches of St Brigid. Clearly, the lively child grew to be a most energetic traveller. But her first cell was at Kildare. With a small group of like-minded women gathered around her, there she sought the blessing of Bishop Mel, a disciple of St. Patrick, as they took their final vows. Worship was central to their community life and schools for enquirers and children were established. But Brigid's greatest legacy was to highlight the abundant grace of God through hospitality. Soon all her settlements became known as havens for travellers, places of gentle care for the sick and generous feeding for poor and visitor alike. Stories of her life abound in such tales as the milking of her cows three times a day so that even unexpected guests could be fed.

Perhaps Brigid had noticed something easily overlooked in studying the Scriptures – that meal tables feature prominently there. On closer examination, we might find that the presence of God was more clearly revealed, more profound teaching was given, and more lives changed at a meal table than in a church or synagogue! In the Bible, food for both body and soul are often closely linked. The meat brought to Elijah by ravens did more than fill his tummy. It brought comfort and encouragement and a new awareness of God's care for him. The fish and bread shared by the disciples among the five thousand families as they sat in groups on the green grass did more than satisfy their hunger. They were all experiencing both the awesome power and tender care of their Heavenly Father as they ate, the teaching of Jesus about him becoming real in their own experience.

These were exceptional events. But ordinary mealtimes abound. Jesus seems to have been a popular guest. We see him at other people's tables on many occasions. And each encounter was life-changing for someone. Zacchaeus was not hectored for his dishonesty as a tax-collector. Jesus' desire to be in his home and the power and purity of his presence were enough to change this selfish man's perception of what was important and to touch him

so deeply that he wanted to give away all that he had previously grasped so greedily.

How lovely, and reassuring, is the account of the wedding feast at Cana. Here we have a host making an embarrassing mistake. In all the rush and stress of planning this wedding – as any bride's mother will well understand – a serious miscalculation had been made. They had under-catered. Perhaps more guests came than expected or they were exceptionally thirsty. Oh, the anxiety and embarrassment when there seems to be too little food or drink to go round! 'Family hold back' is muttered into unwilling ears! But this couldn't be done in John's account – the wine amphoras were already empty. Surely there is a message of comfort to us here, that we don't need to fear heavenly disapproval when we make unwitting mistakes. We can do what the calm, wise Mary did and take the urgent need to Jesus, even if it is caused by some carelessness. Great and important doctrines have been expounded from this passage in John's Gospel, but we can also value the realisation that Jesus is concerned with our entertaining and meal-planning, can inspire us in them and is there to help when mistakes are made.

* * *

Mealtimes were always an important part of the community life of L'Abri, the Christian community founded by Dr Francis and Mrs Edith Schaeffer. They still are, there in the Swiss mountains and in all the other L'Abri branches now scattered around the world. Careful attention was given to making both food and table attractive and welcoming, and meals were a time for good conversation and discussion. But as in all such communities, both time and money were stretched. So meals were a daily challenge for the 'mother' of each chalet.

On one occasion, eighteen were expected for lunch. It had not yet been possible to make the weekly trip down the mountain to re-stock at the supermarket and somehow time-management of

the morning must have been at fault. So, time was short when we began to prepare lunch and realised that the first course planned would be just enough for thirteen. There was no time to make a pudding but quite a lot of chocolate cake was still there from the previous day. I ran a knife over imaginary slices – hmm, about thirteen there too. Fruit would be a good idea... a quick rummage in the fruit and vegetable basket produced thirteen apples.

All of us in the kitchen decided to pray over these alarming lacks as we worked. The phone went and two people cancelled lunch. As we laid the table, another call came excusing a guest. We were beginning to serve, still not knowing quite how to stretch the food over fifteen plates when two students put their heads apologetically around the kitchen door. It was such a lovely day! Could they skip lunch and go for a walk instead? We smiled in relief. There had been no sense of reproof for our failings, just help given, most gratefully received. The mistake and awkwardness had been lovingly dealt with. Even more significant was the dawning realisation among the young helpers, as they took their places at the table ready to enjoy both the meal and discussion, that the Lord had shown himself already to 'be present at our table' – and in the kitchen.

There were numerous experiences of God's care and provision in all the chalets which comprised the L'Abri Fellowship. In an organisation that never appealed for or solicited funds, this daily dependence on a living, personal Father for all that was needed in order to care for guests and students from all over the world, proved to be a powerful witness to his reality, the visible answers to prayer accompanying and supporting the lectures and services.

* * *

Brigid's settlements grew rapidly as she drew into them many Christian women who were otherwise isolated, under pressure to marry against their wills or even persecuted for their faith. The buildings were carefully designed to withstand cold, wet weather,

provide protected walking paths for the nuns, and areas for gardens and animal pens. The large gates were reputed to be always open during the day, for they quickly gained the reputation of being havens for weary travellers. The local poor came for whatever food and clothing could be shared with them and the sick to be treated with gentle care and simple medical help.

Brigid's open doors expressed her awareness of the pattern of hospitality given throughout the Scriptures, from the command to God's people in Leviticus to treat aliens in the land as if they were native-born (remembering their own exile in Egypt) to the oft-repeated enjoinder to practice hospitality in Paul's letters to the churches. The writer to Hebrews goes further, telling all believers: 'Do not neglect to show hospitality to strangers for by doing that some have entertained angels without knowing it.'[4]

But most of all, Brigid was declaring her understanding that the gospel is more than words. Her passion was to demonstrate what the Christian life means. She gave it human expression in ways that a person's senses of sight, hearing, taste and touch could appreciate and absorb. Those who could not read books could still read the love of God in the eyes of those tending their wounds and feel it in their touch. When gnawing hunger was met with milk and bread and vegetables from the garden, hearts were touched, and ears then opened to hear and understand that Jesus is the Bread of Life. It seems significant that our English word 'companion' comes from the Latin meaning 'with bread' or 'with food'.

However, Brigid's gates were shut at night. No doubt this was for protection from wild animals or brigands. But the gates closed were as symbolic of Christian truth as when they were wide open. A family or community needs time alone. A beautifully made cake will be received with delight by anyone invited to tea. A tray spread with flour, butter, sugar and eggs would not be! These ingredients need to be carefully blended and patiently cooked together; then they will feed others. In the same way, it is in the

development of close, understanding relationships between members of the family that resources are created which can then be shared with others. Affection, acceptance and security need to be 'cooked' into the family first. This takes time and loving attention and, when necessary, a determined prioritising of family needs above work or even ministry and a shutting of the door.

In the gospels, we see Jesus frequently retreating from needy crowds to be alone with his Father. At other times he withdrew with a few intimates. The haven he often sought was the home at Bethany of his friends Martha, Mary and Lazarus. Within walking distance of Jerusalem, it was also far enough to provide respite from crowds and noise and constant demands. Probably Martha was a good cook, judging by the care she took over the meal she provided for him, and possibly his disciples, which Matthew records for us. On that occasion she became indignant at working so hard without her sister's help – perhaps forgetting the wise words in Proverbs which recommend a 'dinner of vegetables where love is' rather than a fine meal in an atmosphere of strife.[5]

Both sisters showed deep love for Jesus in contrasting ways at another mealtime, Martha again serving a meal prepared with love, Mary expressing hers by pouring her most precious oil of nard over his tired feet, tenderly wiping them with her hair. Respite, a good meal, loving welcome, generous refreshment – this surely is hospitality.

* * *

The A Rocha Centre in Portugal founded by Peter and Miranda Harris developed around their own family. Peter claims that in this Christian Field Study Centre, his family 'has been made far richer by those who have joined us.'[6] In his book *Under the Bright Wings,* he tells of someone who came from a divorced family. She greatly enjoyed the conservation fieldwork but the most treasured part of her time there was 'being able to belong to an extended family.' Peter comments that 'few of the ideas that have become

embodied in the way we all work at A Rocha are more important to us than the possibilities of being that kind of family to those who stay here. We have discovered nothing particularly profound except that a married couple, with their children if they have any, but equally without if they haven't, can provide a centre of gravity which can give affection, acceptance and security to all those whom the family welcomes into itself.' This is the gift and the effect of true hospitality.

Across the sea from Brigid's Ireland and many centuries later, there lies today another Christian community. In West Wales, a 'Celtic-influenced missional community' also lives to bring the kingdom of God to all who come to visit or stay. In his book *The Grace Outpouring* Roy Goodwin describes the birth of Ffald y Brenin and its gradual development into a place of hospitality in all of that word's rich meanings. When a lady was invited there with a view to her taking the position of cook, she surprised Roy and his wife by saying: 'I would want to see that the philosophy of the food I produced and the way it is presented matched perfectly with the philosophy of the ministry of the house.'[7] These unusual words echoed almost exactly what someone else had recently been inspired to say. They were awed as they recognised a guiding principle from heaven for the meals they would share with guests.

Ordinary Christian families, too, need a philosophy of food. Food programmes on television were once educational, teaching the basics of cooking and introducing helpful recipes to the busy family cook, usually the mother. Many now have changed into something voyeuristic, an entertainment featuring exotic dishes, which satisfy eyes only as they are beyond the finances or time-resources of most people. Some often seem to promote unhealthy self-indulgence rather than wholesome family meals. In one programme, the dining table, which should be a place of welcome, relaxation and enjoyment of both good food and company, is instead a very stressful place, the focus of intense competition and criticism as 'hosts' vie with one another over the food and wine.

What sort of philosophy does this reveal? Maybe it is not shared by many. However, the world around us would squeeze us into the mould of rushed meals, often taken separately by different members of the family following different routines – of 'grazing' even, when hungry people just take from the fridge and eat as and when they wish. Dining tables have disappeared from many homes as people eat on laps in front of the television or computer. In the Bible, as we have seen, meals were a social occasion. Relating to, listening to, giving time to each other – these were as integral a part of a meal as the food. They still are, and the food itself speaks volumes in its planning and cooking and presentation. It speaks either of love and thought given to the family's needs and enjoyment or of a rushed and grudging interruption from other more important activities.

On first hearing, it may seem surprising that the Bible contains detailed instructions on how to lay a table. It was to be carefully laid with roasted lamb, bitter herbs, salt water, and unleavened bread. This table, of course, was the one laid for the Israelites' last meal in Egypt. So significant was it that the Hebrew New Year would from then onwards begin on that day, the day of Pesach, or Passover, and both the preparation and the eating of the meal that followed were to be repeated exactly every year on that day. Every item played its part in reminding God's people of their slavery in Egypt and God's mighty rescue. And each part must be explained to the next generation. When the Lord instructed Moses to daub the blood of the slain lamb on the doorposts of all the Hebrew houses, he made clear that the children must be told its full significance: 'When your children ask you "What does this ceremony mean to you?" then tell them, "It is the Passover sacrifice to the Lord who ... spared our homes when he struck down the Egyptians."'[8]

The most profound revelation of Jesus' love for us was given at this Passover meal table, the simplest foods of bread and wine signifying to us in basic elements which we can see, touch, eat and understand, something of what they mean as his own body, to be

broken on the cross for our sins, and his blood poured out for our forgiveness and cleansing. Our dull minds need such help! The sad couple walking to Emmaus needed them too. As Jesus joined them for their meal, they recognised him when he broke the bread. They never finished that meal because when the sudden light of understanding that Jesus was alive broke in, they rushed away to tell their friends.

For us today, hot cross buns on Good Friday and Easter eggs on Easter Sunday give us ideal opportunities to tell their stories – the cross, the empty tomb, the new life these give us. Home is the place where these truths will be embedded, and our family meals can play a memorable part when we, as Jewish parents still do, use these opportunities to 'tell the children.'

* * *

'The house was filled with the fragrance of the perfume.'[9] So says John after Mary had poured her love-gift over Jesus' feet at this Bethany meal. Perhaps Mary understood instinctively what the Greek philosopher Diogenes noted in the 3rd century: 'When you anoint your head with perfume, it flies away in the air, and birds only get benefit of it, whilst if I rub it on my lower limbs it envelops my whole body and gratefully ascends to my nose.'[10] In fact, the sweet fragrance of Mary's gift ascended to all the people there.

It is interesting that such a small, fleeting sensation should have been remembered so vividly, reported in detail by the disciples when telling their stories to the writer, and still read by millions, centuries later. Its significance was as an anointing of Jesus' body in preparation for his burial. But perhaps the lovely, rich aroma staying in the memory helped to keep it sharply defined.

It is said that the sense of smell is the most potent in recalling early memories. After many decades, the smell of wood smoke still immediately conjures for me the memory of approaching my grandfather's house for the first time at the age of five, curls of the smoke drifting towards us as we caught sight of him in his long garden, forking trimmings and branches onto a bright fire. It was just after the end of World War Two, a very testing time for my family, as it was for many, and somehow a sense of safety and homeliness were and still are conjured with the smell of wood smoke. Mary's expensive gift provoked dismay among the uncomprehending disciples and anger in Judas, immediately triggering his betrayal. So that lovely aroma would forever afterwards bring back vivid memories and mixed emotions to the friends of Jesus.

Aromatherapy is a comparatively new word in the English language. Books and articles are written on the subject, fortunes made, and large amounts of money spent at spas providing massages with essential oils and other therapies to relax and refresh our stressed-out selves. But an understanding of the healing properties of the plants with which the Creator himself has provided us has been with us for centuries. Monasteries throughout the ages have had herb gardens among their vegetable plots. Herbs have long been used for medicine, but they have many benefits other than as physical remedies.

Today our lives are usually urban, noisy and fume-filled. However, without spending on spas and expensive oils, we can provide ourselves and guests with a different sensory environment – a haven if not a heaven. Significantly, the word 'Paradise'- which to

us usually means heaven itself – is said to come from 'Pairidaeza', the name for an enclosed *scented* garden in Persia, 2,000 years ago. There lavender would have had a starring role, spreading its heavenly scent. Oil of lavender was very costly throughout the Middle East and may well have been Mary's spikenard, poured out to Jesus but also sharing its fragrance with everyone there. So a hospitable, welcoming home can also be a little pocket of 'paradise', or at least a hint of it. Lavender by the front door which you brush each time you go in, a pot of hyacinths on the doorstep or inside, rosemary which can be squeezed as you walk past, roses, sweet peas and fragrant pinks – in tiny gardens, on a small balcony or even in a window-box; these things are possible, perhaps even essential to keep us connected to and breathing in the good creation given to us as blessings by our God. Their sweet aromas can be explained as necessary to attract insects for pollination, but surely, they are also love-gifts to ease our stressful days and make us smile.

'He makes grass to grow for the cattle and plants for people to use – to bring forth food from the earth and wine to gladden the human heart, oil to make the face shine, and bread to strengthen the human heart.'[11] The Psalmist realised that so much more is given to us than is strictly necessary for our survival. God gives 'to gladden the heart'. It is not only wine that does this. University research has found that the herb rosemary benefits both brain and mood. Apparently, its essential oil, cineole, when absorbed into the bloodstream through sniffing improves brain performance and memory and also lifts the mood. We can gladden the hearts of our guests too – flowers in their bedrooms, lavender-scented sheets, touches which say 'welcome, you are greatly valued'.

'Let's go to that house, for the linen looks white and smells of lavender, and I long to lie in a pair of sheets that smell so.'[12] This request of Izaak Walton's in *The Compleat Angler* suggests that lavender's soothing scent appeals to both men and women in every age.

'The house was filled with the fragrance of the perfume.' The fragrance of the generous, undeserved love of God for all people was expressed by Brigid in food and warmth and welcome as well as in words. Hospitality takes on a rich significance when we can believe with Brigid that in serving others in this way, we are feeding, clothing, tending and ministering to Christ himself. All the elements of hospitality – feeding hungry people, welcoming strangers, clothing the needy, caring for the sick and prisoners are covered in Jesus' challenging teaching at the end of Matthew's gospel that this service to others also serves him.[13] In other places, he declares that when we welcome children, we are welcoming Jesus himself and his Father into our midst.[14] For those in the most straitened circumstances, Jesus reduces this command of 'hospitality' to the simplest possible offering of a cup of cold water; even this is valued and rewarded by him.[15] When, today, people's ears are sometimes closed to words, maybe other senses can be opened to the awareness of God's love by the warm hospitality of a caring home.

To pray:

O God, make the door of this house wide enough to receive all who need human love and friendship, but narrow enough to shut out all envy, pride and malice.

Make its threshold smooth enough to be no stumbling block to children, nor to straying feet, but strong enough to turn away the power of evil.

God, make the doorway of this house a gateway to your Eternal Kingdom.

(Bishop Thomas Ken 1637–1711)

To do

Think of someone for whom an invitation to a meal would be especially welcome – a lonely neighbour, a recent arrival in this country far from home, students unable to go home in the holidays. Plan a tasty but simple and relaxed meal (so no rushing to and from the kitchen) ... with warmth ... flowers ... perhaps

music ... all phones silenced and left in another room ... time given to listening to their stories ... a chance to share one's own.

To consider:

<u>Celtic Rune of Hospitality</u>

I saw a stranger yesterday
I put food in the eating place,
Drink in the drinking place
Music in the listening place;
And in the sacred name of the Triune God
He blessed myself and my house,
My cattle and my dear ones;
And the lark says often in her song,
Often, often, often
Goes Christ in the stranger's guise.[16]

Notes

[1] Tasha Tudor: First Graces: (Lutterworth) p.18
[2] James 2:14
[3] D. Leatham : *They Built on Rock* p.47
[4] Hebrews 13:2 NRSV
[5] Proverbs 15:7 NRSV
[6] Peter Harris: *Under the Bright Wings*: (Regent College Publishing) p.151
[7] Roy Godwin: *Grace Outpouring*: (David C. Cook):p.178
[8] Exodus 12:25–27 NIV
[9] John12:3 NRSV
[10] Diogenes: quoted by Tessa Evelegh; *Lavender*: Hermes House; p.16
[11] Psalm 104:14,15 NRSV
[12] Izaac Walton: *The Compleat Angler*: quoted by T. Evelegh: Lavender: p.41
[13] Matthew 25: 31–46 NRSV
[14] Mark 9:37 NRSV
[15] Matthew 10:40 NRSV
[16] Northumbria Community. *Celtic Saints*: p.8

CHAPTER 9

ST. HILDA
A WOMAN'S PLACE IS ...

Italian clergy were scandalised. Not for the first or last time, the church in Britain was steadily going its own way, pursuing a path distinct from others in Europe, following its own convictions and quietly ignoring their protests. A monastery had been established on the rugged cliffs of north-east England by Oswy, the Christian king of Northumbria. The ruins of the later Benedictine abbey still tower impressively over the cliffs and town of Whitby while the wild North Sea pounds the rocks below as it did when this windswept place was home to a thriving community of both monks and nuns 1400 years ago. This was the scandal; that it was a double monastery and – worse – that over it ruled an abbess.

Hilda was a high-born lady, great-niece of King Edwin, the first Christian king of Northumbria which was a large area of Celtic Britain stretching from the lowlands of Scotland down to the River Humber. But it was not her nobility that fitted Hilda for the role of abbess of Whitby. The saintly Aidan 'knew her and admired her great wisdom and love of God's service.'[1] These were the words of the Venerable Bede writing in the following century who highly praised her for her many gifts and virtues, saying that 'all acquaintances called her Mother because of her wonderful devotion and grace.'[2]

Hilda was born in 614. Her father, Hereric, was killed in battle when she was young and she and her mother Breguswith lived at

the royal court, there coming under the teaching of Paulinus, who had been sent by Augustine in Kent to be the first Bishop of Northumbria. Both the king himself and his young relative responded to the Christian message and Hilda was baptised in 627 at the age of thirteen. She continued to live in the king's household for another twenty years, but in 647 she renounced her status and possessions and resolved to serve God by joining her sister Hereswith as a nun in a French monastery at Chelles. On her way there she stayed for a while with her sister's son Aldwith who was king in East Anglia. But her plans were changed by the perceptive Aidan. He recalled her home to the north. There she was given land on the River Wear and helped to establish a small community of nuns.

After one year's experience of the religious life with a few companions, Hilda was ready to become abbess in Hartlepool, believed to have been a mixed monastery. It has long been buried under the town's heavy industrial buildings, but the old parish church bears her name, and a seventh-century burial ground has been found there, revealing tomb slabs bearing Christian symbols and even skeletons from Hilda's time. Her eight years there, advised until his death by Aidan himself and by other wise leaders who recognised her devotion and gifts, prepared her for her great life work at Whitby.

However, Hilda's great life work would never have become possible if strictures pronounced across the Channel had been followed here. 'The woman should remain in safety behind the walls of the city. Her chief virtue, her crowning glory, is ever to remain invisible.'[3] This pronouncement by Sulpicius Severus, the fourth-century biographer of St. Martin of Tours, suggests that it was not only women's safety that concerned him. While Celtic and Teutonic people held women in high regard, many others were dismayed at the freedoms they enjoyed in these shores.

The Celtic peoples had long respected their women. Such was their high position that Tacitus noted in surprise that Teutons

'neither scorn to consult (their women) nor slight their answers.'[4] Moreover, Hannibal, when making a league with a Celtic tribe, instructed 'if the Carthaginians have anything to lay to the charge of the Celts it shall be brought before the Celtic women.'[5] In both the Druidic religion and Celtic society in Britain, women enjoyed greater respect and independence than in many other cultures. So when the Christian church was established in these islands, women (though notably not those who had been born or sold into slavery) naturally took their place as equal learners of the faith and, when sufficiently educated, teachers of the faith to others of both sexes.

* * *

For whatever reasons, cultural, psychological or apparently theological, the debate and arguments about the role of women have continued to this day. These ancient differences between Celtic and Greek/Latin views were shared by many other cultures and countries and later affected every Christian denomination. They rage today, at times still inhibiting the full life and witness of the church, and in many cases repressing the gifts of women.

In a university city some years ago, preparations were being made to welcome a well-known and very gifted speaker. A group of women representing most of the city's churches had been meeting regularly for a year to pray and plan for this five-day visit. She was to speak at a supper for several hundred women on one evening, at a meeting of academics' wives on another and to a large mixed group of students at a theological college. It seemed natural to offer her as speaker to the university's Christian Union for their crowded Sunday evening service. To the organisers' surprise and dismay, their offer was refused, as it would have meant a woman entering the pulpit. However, most unusually, that date proved to be free at the city's university church. She was warmly welcomed there and listened to intently as she spoke helpfully and movingly on prayer to a packed

congregation, from a pulpit often occupied by eminent people, including bishops and Members of Parliament and, memorably, by Mother Teresa. There, gender was immaterial; only Spirit-given gifts were welcomed and appreciated.

* * *

Hilda's Spirit-given gifts and knowledge were both recognised and welcomed in the Northumbrian church. She was not only free but encouraged to establish in 657, several years after Aidan's death, the double monastery at Whitby, which became so influential then and for the future of the British church. Some years later, Hilda's abbey was so well respected that she was chosen to host the Synod of Whitby in 664. This Synod changed forever the direction of the British church, bringing it under the greater authority of Roman discipline and tradition and, eventually, losing much of the simplicity, freedom and equality which marked the Celtic church.

However, little was changed in Whitby. Throughout her years there till her death in 680, Hilda continued to exercise a teaching, counselling and leadership ministry which blessed the whole church in England and beyond. She was recognised as a most efficient organiser and a brilliant teacher of men and women. Of the fourteen bishops in the land at that time, five were educated by her at Whitby. No doubt they could have trained elsewhere, but they wisely chose to sit under the best teaching and counsel available, and that was to be found in Hilda's Whitby.

As well as biblical studies, literature and the arts became an important part of life and teaching in Whitby, and Hilda's ministry stretched beyond the lives of bishops and nuns and those destined to be church leaders. It was under her patronage that the uneducated stable hand Caedmon was recognised as having been given a gift from God to sing his praises. She encouraged him to write poetry and sing songs of worship, in words and music that could reach the illiterate as well as the well-educated.

Hilda was not alone. In the enlightened Celtic church of the seventh century, double monasteries flourished. The intensely practical St. Brigid may have invented this arrangement, with monks responsible for the heavy work outside while the nuns worked equally hard at the business of housekeeping. All would be equally involved in teaching, in ministering to guests and in tending those who came for help. The church would be partitioned down the centre, so that they worshipped together but without potential distraction. Since the abbots of monasteries at that time held authority over the resident bishop, the abbess who usually ruled the mixed monasteries would also be recognised as being in complete authority, even over the bishop.

It seems amazing that today, fifteen centuries later, St. Hilda's ministry would not be welcome in parts of today's church, even in England. In some denominations, she would be in submission to men, her role restricted, or in some places expected to be silent. Even in mainstream churches there is debate over roles and authority and 'headship'. A document written by several clergy involved in theological education states the following: 'A woman leading a mixed or male home group on her own cannot model the pattern of relationship and leadership outlined by the apostle (Paul)'; 'women should not be admitted to an office that involves the regular teaching or leading of a congregation;' 'we contend that it is inappropriate for a woman to be a congregational leader in a solo capacity or head of a team ministry'[6] This document allows women to teach other women and children but not men, to pray and prophesy in church under certain restrictions, but at all times asserting the authority and 'headship' of a man.

How could the Celtic church have been so different? Did it not know or believe biblical teaching on the subject? Was it misled or disobedient? We know that the Celtic Christians loved and diligently studied the Scriptures, both Old and New Testaments. Their amazing, illuminated Gospels and the reverence they are known to have shown in their handling of the precious Scriptures say something of the high regard in which they held them. But

more importantly, they reverenced not just the pages but the contents. With few other books of commentary or speculative writings, their source and guide for belief and life was the Bible itself. We must therefore assume that they drew different conclusions from what they read.

It is known that the Old Testament was assiduously studied in the Celtic church, perhaps more so than by many Christians today. Even in that patriarchal world they saw brave, God-gifted women acting independently and valued for their leadership. Miriam was called to lead the children of Israel alongside her brothers Moses and Aaron; Deborah, a prophetess, was called to be a judge in Israel, and her life compares favourably with that of the better-known Samson.

Perhaps the hardest of all assignments given to women in the Old Testament was the task asked of Esther. Few men or women at any time could exceed the courage of this beautiful and humble woman, no personal hopes or ambitions allowed her, restricted to a harem to live entirely for the King's pleasure – even under sentence of death if she approached him uninvited. Esther, nevertheless, with immense courage, wit and faith and with intelligent preparation, dared to ask for – and obtained – the salvation of her people the Jews. She broke through the usually impenetrable 'glass ceiling' of all the laws and customs of that time, even the immutable law of the Medes and Persians. Although not mentioned in the roll of the heroes of faith in the book of Hebrews, she is most worthy to have an Old Testament book named in her honour. This example of courageous obedience to God's call would be known to Hilda and her sisters.

A quieter independence of thought in a domestic setting can be seen in other little-regarded women who, by acting with determination and courage, were instrumental in the salvation of their people. The mother of Moses flouted Pharaoh's laws to save her son, and it must have been trust in her God alone which put

her baby in a little basket at the river's edge. Her husband is not mentioned in this story, but her little girl is. Watchful and quick-witted, she ran to Pharaoh's daughter as she discovered the baby and suggested her own mother as its nurse. These two are unnamed in the Bible, but without their carefully recorded perception, faith and courage, Moses the saviour of Israel could not himself have been saved. Even Pharaoh's daughter acted against her father's edict. Had she consulted him, there would have been no Exodus.

When Celtic women read of the many encounters in the Gospels of Jesus and women, perhaps they were not surprised to see the respect he showed them and the value he placed on them. They saw that the woman of Samaria with the chequered marital history became a believer in Jesus as the Messiah and that she then began to spread the good news in her area, a female 'evangelist' without any male supervision. When Philip later took the gospel to Samaria, he found fallow ground, well-prepared by this unnamed woman's faithful testimony.

Given the observations of both Tacitus and Hannibal on the Celtic custom of consulting their women over all important decisions, they may have felt no surprise that Mary and other women were chosen by Jesus to be the first witnesses to his resurrection or that these women were commissioned by him to go to his frightened male disciples with instructions to go to Galilee. The disciples doubted their word, but Jesus did not doubt their fitness for the task. In fact, Mary was the first person to be entrusted by Jesus with the promise of his ascension. He commissioned her to take this promise to the other disciples, to be their teacher and encourager in the midst of their fear and confusion.

We must assume that the early British Christians also read Paul's letters with close attention both to their doctrinal teaching and to his instructions for the church. But with their innate independence of mind and an attitude which we would now call 'gender equality', perhaps they did not bring to their reading the cultural

presuppositions of those in Greek and Roman society. Perhaps they were neither looking for nor expecting 'hierarchy' for themselves. Given the frequent communication between Britain and Rome, differences in attitudes to women here and there may have been well known – that in the Greek world many women were treated as male property and raised to please men, that they were given little education and not allowed to testify in a court of law as being unreliable witnesses.

The contrast with the way Jesus himself viewed and valued women in the gospels was stark and unmistakable. Throughout the New Testament, they saw women free to learn from his teaching, to live to please God first and foremost and to minister to others in a variety of ways, including teaching. Restrictions apparently placed by Paul in some church situations may well have been read as locally and temporarily necessary for those times and for the culture and customs of those particular places or as addressing specific problems which had arisen. But they read also that Phoebe was deacon in the church in Cenchreae, and, that Paul, when sending greetings to his relative Junia, who had been in prison with him, speaks of her as 'prominent among the apostles'[7] The first convert in Philippi was a woman, Lydia, who led her whole household to faith and baptism and then welcomed Paul and his companions into her home. Priscilla was clearly a leader with her husband Aquila in Paul's work in Ephesus, and even helped to give corrective teaching to the preacher Apollos as they 'took him aside and explained the Way of God to him more accurately.'[8]

Was this couple an inspiration many centuries later for Catherine and William Booth? Together they founded the Christian Mission (later the Salvation Army) in London's East End. Here, after much heart-searching and careful study of the Bible's teaching, Catherine grew to believe that the ministry of women alongside that of men was both Scriptural and essential. After initial reluctance to step forward herself, she at last obeyed a clear call to preach and was soon in great demand. Her extensive ministry brought to faith

thousands of men and women among the poorest and neediest who were unreached by traditional churches. This work suffered much criticism and hostility, but it also attracted the attention and admiration of Members of Parliament, leading Anglican churchmen and even Queen Victoria.

In her pamphlet *Female Ministry* Catherine stated:

'If the Word of God forbids female ministry, we would ask how it happens that many of the most devoted handmaidens of the Lord have felt constrained by the Holy Ghost to exercise it? The Word and the Spirit cannot contradict each other.' She warned that the lack of it meant 'loss to the church, evil to the world and dishonour to God.'[9]

These were no silent women. They certainly were not invisible. Instead, they were examples of the glorious overriding message in Paul's letter to the Galatians that in Christ 'there is no longer Jew or Greek, there is no longer slave or free, there is no longer male and female for all of you are one in Christ Jesus'[10] – and, in the book of Acts, that the Holy Spirit with *all* his gifts was poured out equally on women and men.

It is in the unexpected pages of a 19th-century novel that this truth is expressed with unparalleled, firm simplicity: 'It is not for men to make channels for God's Spirit as they make channels for water-courses and say, "Flow here but flow not there".'[11]

These are the words of Dinah Morris, the unassuming Methodist heroine of George Eliot's novel *Adam Bede*, when questioned closely by the local rector concerning 'a woman's place'. Gentle and modestly dressed, drawing no attention to herself, she yet knew with quiet certainty that God had called her to preach his good news to the poor, on village greens, among the miners, and in poor cottages and that it was always given her when to speak and when to keep silent. It was her direct teaching and kindness and identification with the lost and needy which blessed many men and women who were left untouched by her lofty critics.

Dinah's life has been described as 'a whole, without a split between the sacred and the secular'[12] – an unconscious reflection of the lives of our Celtic saints.

George Eliot is widely believed to have abandoned the Christian beliefs of her young adulthood. Yet on closer examination of her writings, it is clear that some of what she discarded we might also question – the perceived coldness and 'absence of genuine charity' shown by many church leaders – 'the forensic view of justification' that 'dwells on salvation as a scheme' and fails 'to represent good works as the spontaneous, necessary outflow of a soul filled with divine love.'[13] In the patriarchal world of Victorian society, Mary Ann Evans had to use a male pseudonym, as did the Brontë sisters, so that her work would be taken seriously by male publishers. Struggling both to find a Christ-like religion (with limited dogma and full of his compassion) and to use her exceptional gifts in a male-dominated culture, she was able to express both in stories like *Adam Bede* and *Silas Marner* which exemplify deeply Christian themes of redemption. They also portray gifted women, like Dorothea in her most famous book *Middlemarch*, struggling to express her innate creativity and compassion for the poor while loyally supporting her cold, authoritarian clergy husband, engrossed in obscure, fruitless study.

<p style="text-align:center">* * *</p>

Beliefs regarding the ministry of women in the church cannot be divorced from those of their role in the home. The God-given gifts of women and men cannot be treated as of equal value if one of them is to be always 'in authority'. It is the 'oneness' that shines through the beautiful story of our creation. 'God created humankind in his image, in the image of God he created them; male and female he created them,' together expressing something of God's creativity, beauty, love, and caring authority over the natural world, in ways that would be partial, distorted, impoverished by one alone. Indeed, where a man is always 'in

charge' even in areas of home life where he is often less able than his wife, this is the result – impoverishment and frustration.

The disciples had an argument about who should be 'in charge'. This was not about husband-wife relationships but a jostling for a position of power among themselves. Jesus' words to them resound down the ages to us – and have ultimate authority over us – in all our relationships in home, church, and every other situation.

'The kings of the Gentiles lord it over them; and those in authority over them are called benefactors. But not so with you; rather, the greatest among you must become like the youngest, and the leader like one who serves. For who is the greater, the one who is at the table or the one who serves? Is it not the one at the table? But I am among you as one who serves.'[14]

The 'greater' here is clearly someone considered great in the world's eyes, not in God's.

Later, when Paul speaks of 'headship' in the home, he holds up Christ as the model. And what sort of model do we find in Jesus? Not someone who demands a privileged position. We find *'One who serves.'* 'Who, though he was in the form of God, did not regard equality with God something to be exploited but emptied himself, taking the form of a slave.'[15] When they were tired and hot after walking dusty roads, Jesus washed his friends' feet. This was not a ritual or a performance – it was a simple, loving response to a real need. It was also, Jesus made clear, a model for their own caring service to one another, and for ours. When his friends returned after a sleepless and fruitless night of fishing, Jesus had a fire and a hot breakfast waiting for them on the beach. Then he served them, not them him. In Paul's words 'Let this same mind be in you.'

Jesus had spent thirty years in Mary's home. As well as carpentry, he would have learned to cook and all the household skills. If Mary was widowed while still young (as is sometimes supposed)

the eldest son would have been her provider and valued support, probably helping with younger children. Jesus' model of 'headship' is one of practical, knowledgeable and loving service.

It is interesting to note that at Sandhurst, the training establishment for British army officers, the motto is 'Serve to Lead'. Even in the army, by its nature hierarchical, an officer is trained to lead by the force of his unselfish example. Any leadership which is first to face the enemy, the most courageous in dealing with danger or difficult responsibility, the most resourceful in solving problems will be welcomed in an army or a home. These qualities can be displayed equally by men and women.

One outstanding example which challenges conservative views of 'a woman's place' can be found most surprisingly in that same restrictive patriarchal Victorian world in which Mary Ann Evans (George Eliot) wrote of her brave fictional heroines. Josephine Butler stands out among the Christian women of that period who flouted the conventions of the time in order to follow wholeheartedly the calling of their one Master and Lord. Though married to a clergyman and with the responsibility of several children, she was so deeply moved with compassion for the poorest and most despised in society that she worked and fought tirelessly for them, travelling the land and petitioning Parliament till she achieved changes in the law to protect and give hope to women of the streets.

It is hard now to comprehend how shocking Josephine's work and speeches must have seemed in respectable Victorian society and how much painful sacrifice was involved in persisting with her campaign against vociferous opposition. But it was said of her that she lived in the presence of God. It was in deep prayer to God alone that she looked for guidance and strength. While always respecting church leaders, she seemed to have paid little heed to preachers. In her words: 'I have not learned from these ... My appeal is to Christ and to him alone as the *fountain head*

(my italics) of those essential and eternal truths which it is our wisdom to apply to the changing circumstances ... of human society. *His teaching was for all time. Many of St. Paul's counsels were for a given time.*'[16] This conclusion, so unusual in her church and cultural context, with her outstanding work, would seem to place her alongside her Celtic sisters Hilda and Brigid.

Perhaps more unusual even than Josephine's work and convictions were those of her husband, the Reverend George Butler. Maintaining his own more conventional ministry and in spite of much criticism and, probably, considerable sacrifice, he remained comparatively in the background, believing in and faithfully supporting his wife's invaluable public work.

Jesus is our supreme model for sacrificial love – the love that wears a crown of thorns. As Jesus submitted his will to the Father so, to follow in his footsteps, mutual submission is called for in the home. Sometimes the giving way will be for sensible, practical reasons because the other person has greater skill or experience in a particular area, perhaps of finances, understanding of child psychology, gardening or car maintenance! Sometimes it will just be for the good or encouragement of the other person even if it means sacrifice. 'Submit to one another out of reverence for Christ.'[17] .True love in the home will always be sacrificial. In fact, its reality can be measured by willing sacrifice.

As Jesus laid aside his majesty, there will often be a laying aside of rights, ambitions, preferences, for the sake of the other. Traditionally, sacrifices of gifts, intellectual pursuits and interests have most often been made by the wife for her husband's career or ministry, though much has changed in our wider society in recent years. Among Christians, in particular, there is increasing recognition that all gifts are God-given and should therefore be nurtured and used. It is interesting to note that the old Norse meaning of 'husband' was related to farming, as indeed 'husbandry' still is today. As any farmer knows, his own comfort comes last as the land will only produce all it is capable of and truly flourish if given assiduous care, feeding and tending. This is true 'husbandry'.

The saintly Aidan recognised and promoted Hilda's 'innate wisdom and love of God's service', giving her any support or counsel she needed, but fully allowing her freedom to lead. There

is no hint that he, or anyone else, saw her as a rival or competitor for leadership. On the contrary, Bede, echoing Aidan's praise, also noted that 'all who knew her called her Mother because of her wonderful devotion and grace...' Her 'motherliness' was prized as a great virtue by this venerable historian who no doubt recalled that our God has a mother-heart as well as a father-heart.

'Can a woman forget her nursing child, or show no compassion for the child of her womb? Even these may forget yet I will not forget you.[18]

The tender comparison of God himself to a mother with a baby at her breast is echoed again in Isaiah: 'As a mother comforts her child so I will comfort you.'[19] This tenderness is seen most fully in the person of Jesus who overruled his insensitive male disciples and took babies in his arms. He was equally at ease with them as children were with him and demolished their preconceptions of value and hierarchy by showing how dearly they were prized and how they modelled the way into his kingdom.

Since our God is both father and mother in his nature, then women and men together equally reflect his image and must be allowed to do so in fullness, in mutual submission and respect, in the freedom in which Paul calls all Christians to 'stand firm, and do not submit again to a yoke of slavery'[20] of any kind, the Mosaic law or patriarchal hierarchy. Catherine Booth's perception of this deliverance is sharp and unequivocal: 'The Fall put women into subjection, the consequence of sin, but to leave them there was to reject the news of the Gospel. The grace of God restored what sin had taken away so that men and women were now one in Christ.'[21]

The Holy Spirit fell on and filled all classes and ages of women and men at Pentecost and his gifts must still flow unhindered through all. As in St. Hilda's community in Whitby, which became a powerhouse for Christianity in seventh-century Britain, churches

and family homes will be most greatly blessed when they have one Lord only, Christ alone.

To discuss:

*What can Hilda, Brigid, Dinah Morris, Josephine Butler and Catherine Booth teach us?

*Are any adjustments needed in our homes, in our churches?

To read and share where appropriate with our daughters and granddaughters:

Suggested biographies of some brave women achievers in a variety of fields:

* *Science and medicine*: Elizabeth Garrett-Anderson, Madame Curie (children's edition available), Florence Nightingale, Katherine Johnson (NASA mathematician), *101 Black Women in Science, Technology, Engineering and Mathematics* by L.A. Amber

* *Christian mission*: Gladys Aylward, Catherine Booth, Edith Stein, St. Teresa of Calcutta, an anthology of 'Classic Christian Women'.

* *National*: Queen Esther's story; Edith Cavell (WW1 nurse who helped prisoners to safety), Joan of Arc, Josephine Butler, Harriet Tubman (rescuer of black slaves), Amy Johnson (aviator), Elizabeth Fry (prison reformer), women who fought without violence for the right to vote; an anthology of 'Awesome Women' available.

Notes

[1] Bede: p.244
[2] ibid: p.245
[3] D. Leatham: *Rock*:p.205
[4] ibid: p.220
[5] ibid: p.206

6 M. Burkill, D. Peterson, S. Vibert: *Ministry Work Group Statement concerning the ministry of Women in the Church today:* (LT1 *Latimer Trust*)

7 Romans 16:7 NRSV

8 Acts18:16 NRSV

9 Roger J. Green: *Catherine Booth* (Baker Books) p.

10 Galatians 3:28 NRSV

11 George Eliot: *Adam Bede* (Penguin Classics) p.95

12 Peter C. Hodgson: *Theology in the Fiction of George Eliot:* (SCM. Press) p.53

13 ibid: p.5

14 Luke 22: 24–27 NRSV

15 Philippians 2: 5-7 NRSV

16 C. Booth '*Female Ministry*' quoted in Christian History#26, 1990 and in part by Rod Garner: *Josephine Butler: A Guide to her life, Faith and Action* (Darton, Longman and Todd) p.84

17 Ephesians 5:21 NRSV

18 Isaiah 49:15 NRSV

19 Isaiah 66:13 NRSV

20 Galatians 5:1 NRSV

21 C. Booth '*Female Ministry*'

CHAPTER 10

ST. PATRICK

STREAMS IN THE WILDERNESS

On a long, hot coach journey from Amman to Petra in Jordan, crossing mile after empty mile of wilderness, we occasionally spotted in the distance a Bedouin tent amid the dusty mounds, sometimes the outline of a donkey nearby or of a distant human or two. In our air-conditioned coach, quenching our thirst from our plentiful supplies of water, we asked ourselves, 'How ever do they survive? What sustains their lives in this empty desert?'

Our view of this wilderness was of barren tracts of land, sparse, struggling bushes, a place where the sun must burn the skin, hunger gnaw at your body, and thirst become a craving, where stinging eyes would scan the horizon for any sign of hope, comfort or human help.

However, hidden from our distant view, there lay numerous wadis scattered over the Judaean wilderness. Collecting water from occasional rain on higher ground, these pools lie hundreds of feet below steep escarpments of rock which shelter them from evaporation by the burning sun. Those who lived here knew where to find them, travelled from one to another and relied on these hidden pools to survive. They alone, with the vegetation they fed, sustained life for people and animals in this desolate place.

Perhaps it is because water is such a potent symbol of sustenance in adverse circumstances that the Psalmist speaks of sitting by the

river when he recalls his people's bitter exile in Babylon. 'By the rivers of Babylon, there we sat down and there we wept when we remembered Zion.'[1] When their country was invaded, they were torn from their homes, from their Temple, from all that was familiar and valued and from the companionship and security which had sustained their lives. Although not in a physical desert, their exile was like being transported into a human and cultural wilderness.

For a solitary teenager, exile would be especially traumatic. It came at the age of sixteen for the young Patrick. He was born in AD 387 in the west of Britain, probably in Cumbria (though Kirkpatrick in Scotland and Branwen in Wales have also laid claim to his birthplace) to a Romano-British mother Conchessa and father Calpernius who was a deacon in the church, and his grandfather a priest. So, Patrick would have had a Christian upbringing in the fledging British church, while surrounded by a largely pagan culture.

Irish pirates made frequent raids on Britain's west coast, selling into slavery whoever they could capture. When Patrick was seized and sold, he found himself uprooted from all that was familiar and comfortable, including the faith of his parents. It was in this crisis, though, that he would find his own. In his words: 'Before I was afflicted, I was like a stone that lies in deep mire. And He that is mighty came, and in His mercy lifted me up ... fool that I am... After I came to Ireland, daily I pastured flocks. I stayed even in the woods and on the mountains. Before daylight I used to be roused to prayer in snow, in frost, in rain. And I felt no harm, nor was there any slothfulness in me because the spirit in me was then fervent.'[2]

In green Ireland, there were many rivers beside which Patrick could have sat and wept when he remembered his home. But it is clear that while turning to God in his shock and sorrow, he found humbling lessons in them and a new awareness of God's presence and mercy. He had found a deep stream of living water in the desert of his exile.

Having been taught Bible stories at home, perhaps Patrick now took comfort from Joseph. He too was snatched from his home, maybe at a similar age, and sold into slavery. As we follow his story as a servant instead of a favoured son, in a foreign land among strangers instead of a comfortable home, we see Joseph being faithful to his master, resisting temptation and behaving with impressive wisdom and patience even when unjustly cast into prison. Surely, he was exhibiting that trust in the Lord that is so beautifully described by the prophet Jeremiah centuries later.

'Cursed are those who trust in mere mortals who make mere flesh
 their strength
Whose hearts turn away from the Lord.
They shall be like a shrub in the desert
and shall not see when relief comes.
They shall live in the parched places of the wilderness,
in an uninhabited salt land.

Blessed are those who trust in the Lord, whose trust is the Lord
They shall be like a tree planted by water,
sending out its roots by the stream,
It shall not fear when heat comes,
for its leaves shall stay green,
In the year of drought it is not anxious,
And it does not cease to bear fruit.'[3]

Joseph's long years in an Egyptian prison were as severe a test of 'heat' and 'drought' as one can imagine. Questioning or even blaming God would be a common reaction. But his trusting closeness to God was such that he was open to receiving dreams

which helped his fellow prisoners and led ultimately to his own release. Pharaoh's dream of the seven fat and seven thin cows was interpreted by Joseph as plentiful harvests followed by drought. He immediately advised the careful storage of surplus grain in the next seven years to supply the land's needs for the following seven lean years. Pharaoh was awed by Joseph. 'Can we find such a man as this, in whom is the Spirit of God?'[4]

Joseph's story is not just of survival in adversity but of flourishing. As the psalmist wrote of a person's trust in God: *They are like trees planted by streams of water ... in all that they do they prosper.*[5] That 'all' for Joseph even included his unjust imprisonment. It was the growth and development of his relationship with God there that caused him to 'prosper' Later he was blessed with favour, honour and authority second only to Pharaoh's. Having lost his own family, he was then given wife and sons. But above all, that deep relationship with God was what equipped him for the huge responsibility of leading Egypt out of potential famine, enabling even his own people the Hebrews to be saved from starvation. Truly he could say: '*God has made me fruitful in the land of my affliction.*'[6]

Patrick endured seven years of the affliction of slavery, out on the lonely, wooded mountain of Slemish near Ballymena. Though not in a dank prison like Joseph, he had to endure the physical discomfort of cold, rain and snow, his companions the sheep he tended for his master. But instead of indulging in self-pity or daydreams of home, he set himself to learn the Irish language and became fluent in the local Scotic dialect which was markedly different from his own in Britain. This was to be a great asset in enabling his later ministry among these people.

However, the greatest fruit from Patrick's affliction was, as he said: 'The love of God and his fear grew in me more and more, as did the faith, and my soul was so roused that in a single day I have said as many as a hundred prayers and in the night nearly the same. I prayed in the woods and on the mountain even before

dawn.'[7] He was following the example of those described by the psalmist: *'Happy are those whose strength is in you. As they go through the Vale of Baca (or an arid, miserable place) they make it a place of springs.'*[8]

Fifteen centuries later, the people of the island of Jersey could never have imagined that something of Patrick's experience would ever be mirrored in their own lives. Peaceful and untroubled for generations, the even tenor of island life continued in its institutions, its farms and homes and schools, affected more by seasons than by the tensions of the outside world. This peace though was shattered by the fall of France soon after the outbreak of World War Two and the rapid march of German forces across the continent to the Normandy coast, within clear sight of the Channel Islands. It was then an easy journey and a great coup for them to set foot on British soil.

To be suddenly overrun and then ruled by foreign forces is a severe test of morale and courage and faith. Resourceful islanders had to find ways to cope with this unwelcome foreign authority, isolation from England, confiscations of property, food shortages and thousands of restrictive regulations. Worse were the draconian punishments for disobedience – and worst of all was the ruling two years into the occupation which would, for some, mean exile.

In September 1942, several hundred homes in Jersey and Guernsey had unwelcome visitors, German soldiers bringing an order for whole families to leave their homes and to be at the harbour the following day, with one suitcase each. They were to be deported to Germany. The individuals or families selected had close connections with the UK, but the order was probably retaliatory, from fury in Berlin at some commando raids. Although Jersey-born, my mother and sister and I were included with my father in

the order as he was English. So began our experience of sudden exile and 'wilderness'.

Joseph's and Patrick's living conditions were far worse and their isolation from their homes was total. However, some elements of their experience were shared by these deportees – shock and disruption, fear for the unknown future, loss of family and friends and, even worse, of personal independence and any sense of control over their own lives.

However, it is interesting to note in the story of Joseph the same phrase occurring in two contrasting sets of circumstances. After his arrival in Egypt and in Potiphar's household, we read that *'the Lord was with Joseph* and he became a successful man ... the Lord caused all that he did to prosper ... he was made overseer ... put in charge.' The Egyptian sun shone, and life was good! Later, when Joseph's world was turned upside down for the second time, his new security and success again snatched away, we again read *'The Lord was with him'*[9] – this time in adversity, in a dark prison.

There is no doubt that heartfelt prayer was going up in homes and churches throughout the islands for the deported families and our prison walls, too, were pervious; they could not keep out the Spirit of God. In our grimy, rundown castle in southern Germany, he sustained us in countless quiet, unremarkable ways. In the earliest weeks, when hunger was a daily reality, a parcel of good foods, packed up and prayed for by family members at home somehow travelled unchallenged across war-torn Europe and reached us safely. Later the Red Cross sent regular parcels to each person, saving lives and health. The local village doctor was moved to kindness, and helped by our own nurses, with limited resources treated our illnesses, including life-threatening diphtheria and scarlet fever.

The crowded rooms were filled with double bunk beds with straw mattresses and rough blankets, simple benches and tables, the cold reduced by a single stove in the centre. Our room was now 'home'

for thirty-six women and children, eating, sleeping, playing and living together, a disorientating contrast to the comfort and privacy of their own homes. People who barely knew each other were thrust into unwelcome closeness, day and night, linked only by shared shock and anxiety. The sustaining streams so desperately needed were not just for our physical welfare. As in Patrick's case, the Christian faith which may have lain dormant in some lives was now reactivated – quietly, privately, as befitted reserved islanders. The result was that my mother's later memories were largely of kindness and mutual help, making the deprivations bearable in this crowded room for nearly three years.

For two small, frightened children, the presence and love of our parents provided security. But an even deeper stream of comfort than this was needed. The psalmist who sat and wept by Babylon's rivers cried 'How could we sing the Lord's song in a foreign land?' But the Lord was in our foreign land and his songs could be sung. At night as she prayed with us, our mother taught us hymns such as 'Loving Shepherd of Thy sheep, Keep Thy lamb in safety keep. Nothing can Thy power withstand. None can pluck me from thy hand.'[10] One small boy in the room recalled in later years: 'My mother was always a great one for helping others. She would often soothe the little ones by rocking them in her arms and gently singing her favourite hymn 'Lead Kindly Light'.[11] In an environment of armed soldiers with frightening dogs, simple words such as these helped to combat fear and provide a sense of shielding.

Just as Patrick used his exile on the Slemish slopes productively by learning the local language, creative gifts emerged or were developed in amazing ways among the internees. Supplied with paints and brushes by the wise Red Cross, fine artistic work was produced. We small children had Christmas and birthdays marked by lovely cards drawn and painted by people who, in most cases, had never before had time to use such talents. Upcycling became a way of life before the word was generally known! Every Red Cross box and carton, food tins, string, scraps of material and

outgrown jumpers and other garments were all re-worked in creative, ingenious ways so that children in particular were always clothed and even supplied with toys.

An exhibition was held in a Jersey museum in 2012 of artefacts created in the islanders' prison camps. There were hats, belts and dolls made of string and raffia, teapots and mugs forged from tins and fine examples of the cards and paintings. One painting was of Room 56. This was my family's 'home'. Just one homely object can be seen in the stark surroundings, a little doll's pushchair. It was one of two made out of Red Cross crates by my father for my sister and me, his only tools a kitchen knife and broken glass. The small, carefully-crafted and painted sewing-box he also made for my mother remains a treasured possession, testimony to that creativity which is a demonstration of God's image in us. This was one of his sustaining streams, a measure of 'home' in our desert.

There was a further lasting lesson from these years. Somehow these early experiences of seeing broken and outworn items being patiently re-formed into new, useful, and even beautiful things became so deeply absorbed that it became a remembered image of restoration, giving hope and courage not only for broken things but for damaged relationships and broken lives.

Jesus seems to have used this very teaching method. Before calling and commissioning his first disciples to become fishers of men, he gave them an experience of his blessing on their practical everyday work. Under his direction, they hauled in a remarkable catch of fish. Surely this vivid memory would stay with them and give them fresh courage when faced with opposition or an apparent lack of success in their evangelism.

It is a model for parents to follow. Small children seem delighted to hear that Jesus said that even the hairs of our head are numbered. If they can absorb when very young the truth that no detail of their lives is too small to share with him, they will learn to take all their concerns, disappointments, delights, broken

friendships, lost belongings, exam worries and hopes and dreams to him. Perhaps no time of any day in their childhood will be more precious than those unhurried minutes in bed before being tucked up when a Bible story is read, the day's events talked over, and they are helped to pray, trusting it all to Jesus. To experience his help and answers in these little things will be formative, building faith for the much greater challenges of later life.

We do not know whether Patrick had access to any Scriptures. There was already a small, scattered Christian presence in some areas of Ireland, through the ministry of Palladius, who had been sent to that far-off land beyond the Roman Empire by the Pope in the 4th century. But hand-copied portions of Scripture were rare and greatly valued and it is most probable that Patrick needed to rely on his memory of the psalms and gospel chapters he had learned by heart in his childhood. Bereft of any other help, how precious these would have been to him.

* * *

Halfway round the world, and quite unknown to us in our tucked-away, South German internment camp, someone in the Catholic University of America thought with concern about prisoners of war and packed up some boxes of books to send across the Atlantic to the 'YMCA War Prisoners Aid Committee' in Geneva, then to German censors and finally to our camp. Our hastily packed cases had needed to be filled with necessities, perhaps one or two books for the grown-ups squeezed in. Now I held in my small hands two lovely books of stories and pictures for children. Suddenly a happy, safe world, full of colour, loving relationships and stories of faith in Jesus opened beyond our barbed-wire walls.

Internees who had been teachers in Jersey had set up a little 'school' with limited resources, but we children had few other distractions. Between my two-year-old toddlerhood on arrival and the age of five at liberation, the wonderful gift of 'reading' had

123

been gained. Around us our environment was harsh, bare of comfort, the guns and dogs arousing fear in young hearts. But the love of parents, simple hymns and prayers taught to us, the kindness of friends and their creative gifts – and now these precious books – were our hidden 'wadis', sustaining and even enabling us to flourish in an alien land.

* * *

After seven years in Irish servitude, Patrick heard the voice of an angel promising him escape and telling him that a ship was ready and waiting for him. It meant a long and dangerous walk to the coast. He said, 'I had never been there nor had I knowledge of any person there. And I came in the strength of God who prospered my ways for good, and I met nothing alarming until I came to the ship.'[12] Eventually, he was happily reunited with his family in Britain. But there was a far greater purpose for his release, for which he needed several years of training. He went to Gaul to study theology, possibly in the monastery founded by St. Martin in Tours. He knew he had been called back to the land of both his exile and his spiritual formation: 'I seemed to hear the voice of those who were beside the forest of Forclut which is near the western sea and they were crying as if with one voice: "We beg you holy youth that you shall come and shall walk again among us."'

Patrick returned in about the year 432. So began his battle for the soul of Ireland. In one sense his wilderness years were not over. He was again separated from family and congenial surroundings and from the rich teaching and fellowship he would have enjoyed during his years of study in Christian communities in Gaul. He was alone, an outsider, with no ties of kinship which would give him a natural entrance to any community. He faced dangerous journeys, powerful druids, hostile kings and the pagan lives of the people. Even later, when Christian communities had been established across the land, he was conscious of being one of those described by St. Paul as 'not wise ... not powerful ... not noble ... weak...'[13] and was sometimes despised by others as being

uncultured. False accusations of dishonesty even forced him to leave Ireland for a time until he was exonerated. But throughout his battles and sufferings, Patrick's confidence and experience were the same as St. Paul's, that even if he were just weak 'clay', the extraordinary power in his work belonged to God and did not come from him. [14]

Until his death, believed to be in AD 461, Patrick tramped and toiled and preached the gospel, defying rulers and lighting fires of faith and light which drove back pagan darkness and transformed thousands of lives and communities. Like Joseph, God was making him fruitful in the land of his affliction, fulfilling the promise of Jesus: 'Let anyone who is thirsty come to me and let the one who believes in me drink ... out of the believer's heart will flow rivers of living water.'[15] These rivers watered and fed the soul of Ireland even as its rains kept the land emerald-green, so that for centuries its monasteries and leaders were the prime source of Christian teaching and training, sustaining the church throughout the British Isles.

Our 21st-century Western lives might seem worlds away from Patrick's or Joseph's. But there are many kinds of wilderness. Loss of something loved or comfortable or familiar comes to most people, as does sudden illness, divorce, bereavement or some other devastating shock. Both Patrick and Joseph tell us that the Lord is in these places. They show us that in the worst, least-wanted experiences, when our eyes look in vain for human help and comfort, there are streams to be found, streams which will not only sustain us but will overflow into the lives of others.

Desert-dwelling mothers and fathers strive to ensure that their families will survive in their harsh environment. So it will be essential for them to teach their children from an early age where to find the wadis. In our increasingly unsympathetic world, where trouble, opposition and adversity are bound to be met, if we want our children and grandchildren to both survive and thrive in close relationship with their Heavenly Father, we must do the same. In

daily Bible stories and prayer times and bedtime hymns which both comfort and teach, and in our example, we will also teach them where to find the wadis, the life-sustaining streams in the wilderness.

To pray:

*For all the children we know, for opportunities to teach them about the life-giving streams.

*For all who are persecuted, imprisoned, exiled, homeless or in any kind of lonely 'wilderness.'

To do:

With children create a 'redemptive' experience which is also good fun.

*Collect scraps of card, fabric, ribbon, net, wool, carpet off-cuts, string, matchboxes.

*Cardboard 'castles' can be constructed, doll's houses can be furnished, doll's clothes made.

*Tiny 'people' with old-type springless clothes pegs for making kings, princesses, pirates, shepherds, brides ... (pipe-cleaners for arms, a decorative bottle-top for a crown)

*Have a messy afternoon making papier-mâché – moulded onto strong cardboard, dried and painted – which can produce a landscape for cars and all kinds of imaginative activities. Other possibilities abound!

To pray or sing: From St. Patrick's Breastplate (*Hymns Ancient and Modern* no. 655)

I bind unto myself today
The power of God to hold and lead,

His eye to watch, His might to stay,
His ear to hearken to my need;
The wisdom of my God to teach,
His hand to guide, His shield to ward,
The word of God to give me speech,
His heavenly host to be my guard.

Christ be with me, Christ within me,
Christ behind me, Christ before me,
Christ beside me, Christ to win me,
Christ to comfort and restore me;
Christ beneath me, Christ above me,
Christ in quiet, Christ in danger,
Christ in hearts of all that love me,
Christ in mouth of friend and stranger

Notes

[1] Psalm 137:1
[2] D. Leatham: *Rock*. P.60
[3] Jeremiah 17: 5–8 NRSV
[4] Genesis 41:37 NRSV
[5] Psalm 1:3 NRSV
[6] Genesis 41:52 NRSV
[7] E. Culling: *Celtic Christianity*: p.11
[8] Psalm 84:6 NRSV
[9] Genesis 39:2–4, 21 NRSV
[10] Hymns Ancient and Modern 334
[11] G.R.King: *British POW. no 329*
[12] D. Leatham: *Rock*: p.63
[13] 1 Corinthians 1:26 NRSV
[14] 2 Corinthians 4:7 NRSV
[15] John 7:37, 38

CONCLUSION
WHERE DOES GOD LIVE?

When Patrick was talking with the daughters of the High King of Tara, leading them from paganism to Christian faith, this was their question: 'Who is this new God and where does he live?' Patrick's reply was:

'He has his dwelling around Heaven and Earth and Sea and all
 that in them is.
He inspires all. He quickens all ... He sustains all.
He lights the light of the Sun; He furnishes the light of the night;
 He has put springs in the dry land and has set stars to minister
 to the greater lights...'[1]

Patrick and the other Celtic saints from Martin to Hilda, all steeped in the Scriptures, knew God to be above all, the great and glorious Creator of all things. They were also deeply aware of his continuing care for and life in all things. While rejoicing in his creation and glimpsing his glory there, they could both simply trust him for the supply of their next meal and testify to the richness of his gifts in the exercise of their own creativity in, supremely, the glorious, intricate work of illumination of their beloved scripture manuscripts.

We have some lasting symbols of the Celtic understanding that the whole earth and everything and everyone in it is the Lord's – married to the centrality of their belief in Christ's work of redemption of the whole world and all who live in it. These symbols stand high and impressive in some of our remoter landscapes. From the Scottish Isles to Cornwall, High Crosses can be found, awe-inspiring and mysterious. How did they develop, why were they built, and what do they say?

Before the light of the gospel shone into their darkened minds, the people of this land struggled to make sense of the world around them and to reach out to the powers above and beyond it. Huge effort and planning and backbreaking toil went into the erection of the gigantic standing stones which can still be seen as evidence of their search. However, in the areas most influenced by the Celtic missionaries, we also find High Crosses. They may not have seemed too alien to the people. It was typical of the Celtic mission that the Christian message was embedded into the people's culture, into forms that were familiar to them. To wondering viewers, these crosses would have had some visual connection with the Druidic megaliths with which they were familiar. But their shape and structure spoke a very different message, resonant with hope and love. From Cornwall, through Ireland and Wales and the Isle of Man to Scotland they speak not of a fearful mystery but of the one God above and beyond all, both Creator and loving Father who reaches out to, and in Christ has come down to find and save His people.

The cross itself speaks of Christ's redeeming work, linking heaven with earth and with arms outstretched to embrace all. Many of them were carved with biblical scenes. Old Testament scenes seemed to have been chosen specifically to portray salvation – Jonah saved out of the belly of the large fish, David the shepherd boy rescuing his sheep from the mouths of lions and bears, or Daniel kept in safety in the den of lions.

But the distinctive feature of the Celtic High Cross is its circle. This may have had a practical purpose, helping to support the heavy arms. But the Celtic imagination seemed never to waste any shape on purely practical use, and the circle seems rich in symbolism. Many meanings have been suggested and all may contain truth:

... a round sun speaking of Christ as Light of the world,

... an unbroken ring foretelling the future unity of all things when our Saviour returns,

... an image of the earth, or of the whole universe, cut through by the cross.

This last is perhaps the most telling of all, the most expressive of the Celtic Christian mind – the whole of God's creation, fallen but redeemed and transformed by Christ's death and resurrection. It was also God's home. They had no cathedrals, very few and very simple churches. They had not fallen into the later trap of believing that God lived only in churches. No, the whole of creation was his cathedral, his dwelling place.

'The God of heaven and earth, of sea and river, of sun and moon and stars, of the lofty mountain and the lowly valley, the God above heaven, the God in heaven, the God under heaven.'[2]

But their clear belief in God's transcendence did in no way preclude their faith in his immanence. Living simply and often austerely, eschewing the pride of high position, they knew the reality of the words of God spoken by Isaiah: *'I dwell in the high and holy place, and also with those who are contrite and humble in spirit, to revive the spirit of the humble and to revive the heart of the contrite.'*[3]

The circle speaks also of security and safety, an enclosure in which to rest, similar to a sheepfold for the Lord's sheep. The now-familiar prayer based on the 'lorica' or protective breastplate on which St. Patrick's hymn is based, has come to us from the oral Celtic tradition.

Circle me, Lord, keep protection near and danger afar
Circle me, Lord, keep hope within, keep doubt without
Circle me, Lord, keep light near and darkness afar
Circle me, Lord, keep peace within, keep evil out.'[4]

* * *

Lastly, could we also see the circle which holds (or is held tightly by) the High Cross, as an image of the family circle? Focusing down from God's created universe to the individual people in it, we find families. Could they be a place where God lives?

A remarkable event occurred in the history of the Roman Catholic Church in the summer of 2001. The Vatican announced that an Italian couple, Luigi and Maria Quattrocchi, were to be put on the road to sainthood. They had not lived the life of hermits or taken the gospel to remote and dangerous places or even run large projects in their own town for the poor and needy. The extraordinary justification for their beatification was 'the way they fostered a strong sense of Christianity within their own Italian home.'[5]

Whatever differing or even disapproving views many may have on the 'beatification' by the church of fallible human beings, Pope John Paul II was here elevating family life out of the ordinary and mundane. He was rescuing it from the fringes of importance in our career-focused and success-oriented culture by urging the understanding that 'the family is the first and most important' of the church's mission. He called people to *'embrace your role and responsibilities there'*.... 'making your home privileged places, announcing and accepting the gospel in an atmosphere of prayer.'[6]

In Pope John Paul's homily on the Quattrocchis' beatification, he described Maria as 'a housewife of great culture and profound faith.' She and Luigi raised four children, three of whom became priests. The couple 'made a true domestic church of their family, which was open to life, to prayer, to the social apostolate, to solidarity with the poor and to friendship.'[7]

These words echo much that has been said of the Celtic communities, from Martin's 'Big Family' in Tours to Hilda's in Whitby. It was on a far smaller scale and was not a perfect home;

neither were the monastic communities; nor will any of ours ever be. But the Christian teaching and prayer for and with the children, warm hospitality and care for the poor were at least glimmers of that light which shone from Ninian's Whithorn out into the west of Scotland. Jesus' teaching speaks of a lamp which is meant to be lit and placed where 'it gives light to all in the house', words which indicate the family first. [8] In Luke's gospel, the lamp is put on a stand 'so that those who enter may see the light'[9]; it is shed on visitors to the home too.

On the banks of the River Shannon lies Clonmacnoise, almost at the centre of Ireland and once at the pivotal point of north-south and east-west roads. Now bypassed by major routes, it is a lovely, peaceful place. A fine monastery was started there on a bend of the river by St. Ciaran in the 6th century and it grew to great importance. However, it suffered repeated Viking raids and the churches and other buildings were reduced to ruins. Still standing though are three High Crosses. One, the Cross of the Scriptures, is one of the finest in Ireland. In pre-literacy days it was a silent teaching aid, carved with depictions of Christ's crucifixion and his sitting in judgment of the earth. Now, in the midst of both the ruins of fine buildings and the unchanging beauty of God's creation, it stands as a testament. Christ's redeeming cross and his circle of protection have withstood all onslaughts. It gives courage to believe that his light cannot be extinguished.

Pope John Paul II said of the Quattrocchis that 'they kept the lamp of the faith burning – 'lumen Christi' – and passed it on to their four children.' Maria 'brought them up in the faith so that they might know and love God ... and also handed a burning lamp to friends, acquaintances and colleagues.' Although Maria 'made many mistakes'... (as we all do) 'because educating children is the art of all arts' ... she and Luigi 'dedicated themselves generously to the children to teach them, guide them and direct them to discovering his plan of love.' To use their own phrase, they aimed to train them to 'appreciate everything from the roof up.'[10] Clearly, the light of Christ shone in this family circle and

withstanding storms and pressures from without, radiated it to others.

Where does God live?

On holiday in Wales one summer, we planned a drive to the little city of St. David's, looking forward to the glorious scenery on our route. However, thick cloud descended as we drove, shrouding the hills along the way and, on our arrival, bringing lashing rain which obscured the cliffs and bays around the small ancient city. It seemed to be a disappointing visit until we approached St. David's Cathedral. As we opened the door, we heard most beautiful music, a pure soprano voice which soared to the rafters, then joined by a Welsh male voice choir, singing with the richness and passion perhaps found only in Wales 'I'm but a stranger here ... Heaven Is my Home.' There were visitors there, some in a little shop at the back of the cathedral, but everyone stopped and fell silent. The rich music of voices, harp and trumpets grew to fill every corner of that ancient building, but above it all there came the clear words which so deeply moved us and many others.

The Bible opens a few windows into that glorious place where there is no more pain or sorrow or sighing, where the Lord is seen in all his beauty, where 'home' is being prepared for each one of God's children. The glimpses of heaven we have seen in Celtic communities will be eclipsed by the reality of all generations, all nations, all tribes and races welcomed with the warmest hospitality by the Lord Jesus himself to 'eat and drink at my table in my kingdom'.[11] Those who have hungered will be fed, those who have laboured will be rested, those who have served others will be served. All tears will be wiped away and the losses and pains of this life will be swallowed up in worship and joy beyond description. This is the place Paul speaks of as being 'at home with the Lord.'[12]

But in the meantime, Paul says that while we are still here on a flawed, imperfect earth, with flawed, imperfect people, 'You ... are built together spiritually into a dwelling-place for God.'[13] And the

last word on where God lives is from Jesus himself: *'Those who love me will keep my word and my Father will love them and we will come to them and make our home with them.'*[14]

To reflect and pray:

God to enfold me, God to surround me
God in my thinking, God in my speaking,
God in my watching, God in my hoping,
God in my life, God in my lips,
God in my soul, God in my heart.
God in my sufficing, God in my slumber,
God in mine ever-living soul, God in mine eternity.[15]

Notes

[1] E. Culling; *Celtic Christianity*: p.15
[2] ibid: p.14
[3] Isaiah 57:15 NRSV
[4] E Culling: p18
[5] Homily of Pope John Paul 11 21/10/01
[6] Homily of Pope John Paul 11 21/10/01
[7] Homily of Pope John Paul 11 21/10/01
[8] Matthew 5:15 NRSV
[9] Luke 8:16 NRSV
[10] Homily: Pope John Paul
[11] Luke 22:30 NRSV
[12] 2 Corinthians 5:8 NRSV
[13] Ephesians 2:22 NRSV
[14] John 14:23 NRSV
[15] A. Carmichael: *Carmina Gadelica*: p.204

Notes

Notes

Notes

Notes

Lightning Source UK Ltd.
Milton Keynes UK
UKHW012119220621
385966UK00001B/16